WHAT THE BIBLE REALLY SAYS ABOUT WOMEN

Tony Lang

... this is what was spoken by the prophet Joel:
In the last days, it will be, God declares,
that I will pour out my spirit upon all flesh,
and your sons and your daughters shall prophecy ...
Acts 2:17 (NRSV)

ISBN 978-0-9808228-5-4

Website: lachlanness.com

Unless otherwise stated, all scriptural texts in this book are from the New Revised Standard Version of the Bible (NRSV).

Website: lachlanness.com

Cover design: Helen Marshall
helenm43@bigpond.com

NATIONAL LIBRARY OF AUSTRALIA

A catalogue record for this book is available from the National Library of Australia

I dedicate this book to all women;
especially those who are oppressed and hurting,
in whatever way.

To the Queenes most
Excellent Majestie.

Behold, great Queene, faire Eues Apologie,
Which I haue writ in honour of your sexe,
And doe referre vnto your Maiestie,
To iudge if it agree not with the Text:
And if it doe, why are poore Women blam'd,
Or by more faultie Men so much defam'd?

By Æmilia Lanier 1569-1645,
one of the first feminist writers in England -
a stanza from her poem of the above name,
written for Queen Elizabeth I

Special Thanks

I would like to express my special thanks to all who in so many ways have encouraged me in the writing of this book, which I must say has not been an easy task. My wife Janet and our children have been right behind me, as has my brother Bill. His willing and helpful input on the technical side as well as literary advice has been invaluable. The local branch of the Fellowship of Australian Writers has been of enormous assistance in critiquing much of the work.

As well, I would like to thank all the academics and writers mentioned in the pages of this book whose work I acknowledge with deep gratitude. Their combination of books, e-books, magazines and online websites has supplied so much in the way of information and ideas, without which this work would be so much the poorer. I would also like to thank friends Mike and Antoinette Foley, both academics who as well as critiquing the book have been so supportive with advice and encouragement. Can't miss out on Helen Marshall, a friend and graphic artist who designed the cover of this book as she has some of my other books. Helen is a whizz, coming up with new ideas all the time. Then there is Heather, whose work on the referencing was invaluable. All the above-mentioned folk and many more – friends and family - have given me a sense of fellowship, for I like to think we are all working together, all on the same side, all part of a very special team, holding fast to a very special future dream for womankind.

Finally, I would like to thank my good friend, Dr Christine Dunn, whose chapter is included in this book under her own name. Her clear-sighted and brilliant mind has been a tremendous asset when we've discussed in person, by phone and internet, various matters pertaining to the writing of this book.

Thank you everyone. May God bless each one of you.

Contents

FOREWORD

As you read this book and absorb the stories of all the women mentioned, note how each one of them was a special servant of God, open to His leading. Some were quiet and unobtrusive, such as Ruth. Others were anything but quiet and unobtrusive, such as Deborah. Each in her own way had an important impact on the history of Israel's Covenant with God, and through Israel to the new Covenant in Jesus Christ, and finally on world history.

When we turn to the Gospels and beyond, we find the same message. God shows no discrimination. Both men and women are called to serve Him. Moving on to the early church, again we see women called as prophetesses. We see women dying in the fires of persecution, martyred alongside men. It's an amazing story, told in my poor words. I wish I had time and space to mention all the women who have had such an impact on lives, in the Church and in history, but there are too many countless thousands of them. Yet all through history, this side of the Garden, men have sought to subjugate women, even to the present day, ignoring their gifts, claiming they have a right. Well, it's not a right and it's not right. I hope this book will help make that clearer to some.

Please don't read this book with a closed mind. The book is for *everyone*. It's written for women in the Church who are unable to participate in leading roles because of their gender. It's for those who believe men have a God-given right, in their reading of scripture and the doctrinal position of their denomination, to treat women as subordinates in the life of the Church and in personal relationships. It brings solid evidence from scripture for those who support women's rights within the Church community to participate at all levels in the life and witness of the Church. It's also for those who feel confused about the issue and are not sure which path to take. I hope this book will help your understanding. It's also for those outside the church

community who are treated as subordinates – and there are plenty of those.

Do you know the story of Pentecost? (Acts 2 – the whole chapter). That's when the Christian Church was born, fifty days after the Resurrection. God's people, (men and women, see Acts 1:14,15) were in the one place when the Holy Spirit descended in wind and tongues of flame and fire, and all were filled with the joy of the Holy Spirit. Peter stood to tell everyone that the prophecy of Joel was being fulfilled:

In the last days it will be, God declares
That I will pour out My Spirit upon all flesh,
And your sons and your daughters shall prophecy,
And your young men shall see visions,
And your old men dream dreams.
(Joel 2:28,29).

Wouldn't it be wonderful if the Christian Church around the world retained that sense of joy, as at Pentecost, spreading the Word far and wide, unfettered by and irrespective of, the gender of the proclaimers? Many would regard that as no more than a 'pipe dream' but God has shown over and over that nothing is impossible for Him. In 1904 there was an amazing spiritual revival in Wales. It spread all over the country as men and women rushed out to spread the Good News of God's love, grace and salvation. It was almost like Pentecost all over again. The old had passed away – the new had come (2 Cor. 5:17).

In the very early church, women preached and taught, as this book will make plain, unfettered by what was to follow. It was not until the church began to grow that rules began to appear ... rules, for instance, influenced by the dominant Greco-Roman society which was the culture of the day, that said that women should not preach or teach - well, no one but other women. The Church became burdened with unnecessary laws and rules. While laws and rules are necessary, isn't it a pity that among the necessary laws and rules of the Church,

other laws and rules were put in place, denying women what initially had been theirs?

Commencing in the Book of Genesis, where we learn of Eve's perceived sin; when God kicked Adam and Eve out of Eden, (Genesis 3:16-24), women have been regarded as lesser creatures within the full life of the church. Around the world, women in many denominations and in society itself - are frequently penalised for no other reason than their gender. Natalie Watson writes, 'The unity of the church is often expressed as the supreme desirable characteristic, yet in women's experience it is also often used as an excuse not to hear the voices of women, and as permission to deny the gifts and vocations of women in the church; for example in the debate on the ordination of women'.[1] Those words, sadly, reflect what is still happening in the Body of Christ.

This book had its beginning in my mind some years ago, as I began to contemplate the situation of the role of women in so many denominations who are denied leadership roles, including ordination and even chairing committees if they include males. It seems to be alien to what I believe is God's desire for humanity. I believe God created us, male and female, and He created us to be the equal partner of the other. To make one inferior to the other – and there is no way one can escape that ultimate conclusion – is fraught with danger. Sinful humanity has a habit of drifting downwards when given moral choices. An example lies in the Dutch policy of 'voluntary euthanasia'. According to the Hague 'involuntary euthanasia' is out of control in Holland: Dr Henk Jochensen, of the Lindeboom Institute, and Dr John Keown, of Queens' College, Cambridge carried out the study. They conclude: 'The reality is that a clear majority of cases of euthanasia, both with and without request, go unreported and unchecked. Dutch claims of effective regulation ring hollow'.[2] This book is not about

1 Natalie K Watson,, *The Routledge Companion to the Christian Church.* Gerard Mannion and Lewis S. Mudge, editors. (New York, Routledge, 2010) 468

2 www.euthanasia.com

euthanasia but it's an example of what has happened in other cases where moral choices are made outside God's laws. Over the years there have been increasing numbers of reports of violence against women, family violence, glass ceilings, sexual assaults…'every woman lives with the constant tinnitus hum of low-level sexism. Most of us have been leered at or leched over and told we should be flattered by the attention'.[3] much of this I believe can be traced back to an ingrained belief that women are of less worth than men.

Today, God is speaking to the Church, calling her from a time when women in ministry were unknown in mainstream denominations. Change has been in the air for some time as the Holy Spirit breathes new life into the Church, in line with changing times. Quite a few denominations are ordaining women to the ministry and priesthood. There are women bishops and moderators in some denominations. For women in other denominations there is an ecclesiastically ordained 'glass ceiling'. Based on my understanding of scripture, I do not believe any denomination should have such unfortunate restrictions. Women in some denominations are automatically ineligible for leadership roles, regardless of past achievements, high academic qualifications or a sense of Call. There are ministers who do not permit women to take up the collection. I know of one case where a minister's wife is not permitted to speak when there is a man in the room. It's bizarre. It's not biblical. There are churches where women are not permitted to read the Bible in public worship services. I imagine this must have something to do with 1 Timothy 2:9-15, which will be discussed later. To refuse women permission to read the Bible to a congregation must be regarded as nothing short of bizarre. Many gifted women have left denominations that support such rigid and obsessively narrow understandings of scripture, to go to other denominations. Moving to another church does not heal feelings of being found less than worthy because of gender. Many feel hurt. Some blame God. Others blame St Paul. All are mistaken, as I hope to show throughout this book.

3 Catherine Mayer, *Attack of the 50ft Women – How gender equality can save the world* (London: Harper Collins, 2017), 13.

Women have shown their mettle and won their right to leadership roles within the Church. In many places around the world, the Christian Church has blossomed through the sacrificial work of women missionaries. Many have died in places such as leper colonies, where only the missionaries would stay to nurse the sick and dying. Many became infected themselves, rather than leave the diseased to their fate.

It has troubled me deeply over the years; the idea that, much as we may laud them for other achievements, in some denominations, women are considered lesser creatures when it comes to serving God as ordained ministers, or in positions of leadership, while many male ministers are totally opposed to women even serving as elders or in any leadership roles. That attitude has made its way elsewhere in the wider community. Across cultures women are made to feel less worthy than men.

Each morning my wife Janet and I start the day with a devotion from 'Our Daily Bread'. She reads the lesson for the day, and also the story that goes with it. I close with a brief prayer. For a man to be ministered to spiritually by his wife is a special privilege. At the end of this life I would like my wife to be reading to me from God's Word, should I die first.

God has blessed the work of our women as they brought the Gospel to all sorts of people. In many of these places because of their dedication … *a light has dawned* (Isaiah 9:2). Why would He not bless their work in the established Church? One suggestion I have is from the Book of Acts, where the Apostles are dragged before the Council, where they faced death for preaching Christ raised from the dead.

One wise Pharisee, a chap named Gamaliel, intervened: … *in the present case, I tell you, keep away from these men and let them alone; because if this plan or this undertaking is of human origin, it will fail; but if it is of God, you will not be able to overthrow them – in that case you may even be found fighting against God!* (Acts 5:38)

I can think of no better argument than that; nor could the members of the Council. After ordering that the Apostles be given a jolly good flogging, they released them. (Acts 5:40).

Today, gender inequality permeates, like an unpleasant odour, the wider community as well: glass ceilings, less pay for the same work, workplace bullying and even worse, various other subtle attacks on women and their dignity as fellow human beings. All that is totally opposed to what God intended, so let's take a closer look at what the Bible *really* says about women.

My plan for this small work, while deferring to the original languages and acknowledging the work of Old and New Testament scholars, is to make it eminently readable; conversational, a little humorous at times, but solid in its biblical scholarship and firm in its conclusion: the biblical evidence that in the witness and proclamation of the Word of God, we are *all one in Christ Jesus* (Galatians 3:28).

Rev Tony Lang OAM

PREFACE

GOD: MALE OR FEMALE?

As a mother comforts her child, so I will comfort you …
Isaiah 66:13

As a father has compassion for his children, so the Lord has compassion for those who fear Him … Psalm 103:13

Let's give some thought to the Name, 'God'. Is God male, female or neither?

In Exodus 3:1-15 we read how God confronted Moses in the burning bush, and told him that He was going to send him back to Egypt, to ask Pharaoh to free the Hebrew slaves. Moses wasn't happy about it, for he was wanted on a murder rap back in Egypt.

He questioned God. If I come to the Israelites and say to them, 'The God of your ancestors has sent me to you' and they ask me, 'What is His Name?' What shall I say to them?

God said to Moses 'I AM WHO I AM … Thus you shall say to the Israelites I AM has sent me to you. … That is My Name forever. And this My title for all generations.

The name of God, I AM (always in capitals) is God's Name. The Name is continually in the present tense – God is the ever-present One, unto all generations. The Name is neither male nor female. It is translated from the Hebrew YAHWEH or YHWH.

It's a vexed question for those engaged in the feminist debate, for traditionally the Bible describes God as male, which is the interpretation from the Hebrew and Greek. What name to call God when referring to God in the third person appears to be unresolvable. The NRSV found no acceptable alternative, so simply uses the masculine singular third person: 'his', 'him', 'he' as interpreted from the original languages.

Writers sympathetic to the feelings of the feminist movement, avoid using pronouns when referring to God in the third person and simply use 'God' 'thus conveying the theological affirmation that God is beyond human categories of gender'.[4] It is rather clumsy. As an example, if writing about someone whose name was Jim and we wished to avoid speaking in the third person, it would be possible to have a sentence such as: 'Jim was feeling hungry so Jim drove Jim's car to the café where Jim bought a meal that was too large for Jim, but Jim ate it all and later Jim felt sick'. It's a little disconcerting, isn't it?

I find non-use of the third person singular awkward. It jars. Apart from being rather ridiculous, it disrupts my concentration when reading. One Roman Catholic feminist liberation theologian, Elisabeth Schüssler Fiorenza, has her own pronouns when referring to God in the third person: s/he; s/his; s/him, which is clever.[5] Man becomes wo/man.

The bottom line is, there is no universally satisfactory answer to this problem; also acknowledged by the editors of 'The Women's Bible Commentary' when referring to this issue: 'Interpretation itself is thus an active project, undertaken in a particular context, in dialogue with many partners both ancient and modern, and with the pastoral and theological purpose of hearing and sustaining a word of healing and liberation in a hurting world'.[6]

The Roman Catholic feminist theologian Karen Armstrong writes 'Feminists are repelled by a personal Deity who, because of 'his' gender, has been male since … tribal, pagan days. Yet to talk of "She"… can be just as limiting, since it confines the illimitable God to a purely human category'.[7] It is obvious that there is no satisfactory answer to this problem that will please everyone.

4 Carol A. Newsome and Sharon H. Ringe, Sharon H, eds., *The Women's Bible Commentary* (London: SPCK, 1992), 8.
5 Elisabeth Schussler Fiorenza, *Bread Not Stone: The Challenge of Feminist Biblical Interpretation* (Boston: Beacon Press, 1984).
6 Newsome and Ringe, *The Women's Bible Commentary*, 9
7 Karen Armstrong, *A History of God: from Abraham to the Present: The 4000 year Quest for God.* (London: Mandarin, 1993), 2.

In view of the fact that this book is not about feminism, but what God really has to say about the roles of women in the scriptures, I'm going to follow what the New Revised Standard Version (NRSV) of the Bible does by referring to God in the third person as 'He, His, Him', which is far less complicated. We know that God does not have a gender – God invented gender in the first place! After all, the Creator of the universe created male and female. Thus, while referring to God in th` third person as He, His or Him, we also know that 'He' transcends gender. He is both mother and father to us all.

PART 1
LOOKING AT THE OLD TESTAMENT

GENESIS

'Genesis' means 'beginning' and so I suggest that the best place to commence our thoughts is right back at that ancient, first book of the Holy Bible.

Many are deeply puzzled by the Genesis story as a reason for making females subordinate to males. Eve copped all the blame – and still does – even after all these years! To play the blame game seems a very precarious reason for insisting that women must have a subordinate role. Let's take another, deeper look at the issue, and for that I am going, first, to turn to the work of a noted Australian scholar and author: Andrew Sloane.

Dr Andrew Sloane, author of *At Home in a Strange Land: Using the Old Testament in Christian Ethics,* and *Tamar's Tears* is a lecturer in Old Testament and Christian Ethics at Morling Theological College Sydney. He has produced a brilliantly measured reply to the traditional patriarchal argument in a section of his book headed 'Genesis 1–3 and Gender Relationships'.[8] I know of no better work than his, in challenging the arguments that some put forward as offering reasons why women should be subject to men.

Sloane writes of the five arguments the 'subordinationists' as he calls them, use to support a patriarchal position. He rejects them and has put forward five counter arguments which I will briefly outline here. For a much more detailed explanation I suggest that you read his book, which is readily available as a hard copy or on your ebook reader. It's well worth it.

8 Andrew Sloane, *At Home in a Strange Land: Using the Old Testament in Christian Ethics*, (Grand Rapids: Baker Publishing Group, 2008), 159, Kindle Edition.

The first argument: Women were created to be man's helper (see Genesis 2:18), and so she is his subordinate. The Hebrew word for 'helper' is *'ezer*. That the helper is subordinate to the one being helped is a common assumption. Servants help masters. Subordinates help superiors, as they are paid to do. A woman's help is to be a wife and mother.

In his reply to the first argument, Dr Sloane points out that the word *'ezer* does not imply a subordinate position at all - and in fact may well prove to be the opposite! He writes that the same word is used when God is referred to as humankind's helper. See Exodus 18:4; Psalm 70:5b: *You are my help* ('ezer) *and deliverer; O Lord, do not delay!* Psalm 121:1,2: *I lift up my eyes to the hills – from where will my help come? My help comes from the Lord, Who made heaven and earth.* See also 'the stone of help' narrative in 1 Sam. 7:12.[9] (The name 'Ebenezer' means 'Thus far has the Lord helped us'). Who would want to claim that God is subordinate to them? The patriarchal argument crumbles before an understanding of the original Hebrew text.

On the other hand, it is not to be assumed that the woman is superior to the man. Let's look again at the text: *Then the Lord God said, 'It is not good that the man should be alone. I will make him a helper as his partner'.* (Genesis 2:18). 'Partner' is the translation used by the NRSV for the Hebrew word, *kenegdo*.[10] The literal translation is along the lines, 'hard up against' or 'side by side'; in other words, equals. When I see the word kenegdo I have a mental picture of a brick wall; each brick supporting the other, hard up against the other, side by side, each needing the other, none superior to the other. That's *kenegdo*.

The second argument: As man was created first, it follows that man must be the superior.

Sloane points out, however, in Genesis 1, through to chapter 2, verse 3, the last is created first; that is, humans were created after the

9 Ibid. page 162
10 Ibid.

animals. Does that mean that humanity is inferior to the animals? That argument cannot be used.[11]

The third argument: Because woman was taken from the man's rib, so she must be subordinate to him.

Sloane explains that there is nothing in those words to suggest a hierarchical order. Man's substance is from the ground - but he is not subject to the ground. The woman is dependent for her existence upon God, not the man.[12]

The fourth argument: Man named the woman, so she is subordinate.

Sloane's reply is to refer the subordinationists to Genesis 16:13, where the woman Hagar gives God a name – and Hagar certainly has no authority over God.[13]

Hagar, the runaway slave-girl, had an encounter with God in the wilderness. '*So she named ADONAI* (that's one of the Hebrew names for God) *Who had spoken to her, El Ro'i [God of seeing], because she said 'Have I really seen the One Who sees me [and stayed alive]?'*[14] Genesis chapter 16 covers the story.

The fifth argument: Woman is weaker and more susceptible to temptation.

Sloane's reply: The literal story tells us that the man goes along passively. 'Hers is the sin of action – his the sin of acquiensce. Further, the text makes it clear that he is equally culpable for the sin, and equally liable to God's penalty; he was there all along (Gen 3: 6): *"and she gave also to her husband who was with her"* [emphasis mine (Sloane's)]. How does that establish that she is naturally weaker than the man and more susceptible to temptation, let alone that all women are?'[15]

11 Ibid.

12 Ibid., 164.

13 Ibid., 165.

14 David H. Stern, Trans., 'B'resheet (Genesis)' in *Complete Jewish Bible Translation, (*Clarksville MD USA Jewish New Testament Publications 1998).

15 Sloane, *At Home in a Strange Land,* 165.

The words 'who was with her' definitely suggest that at that point she was the proactive one and he was tagging along.

The final argument: 'Integral to the man's sin is that he listened to his wife over whom he should have taken authority'.

Sloane points out that the text does not establish a creational subordination to the man that was broken in sin and needs to be re-established by God after the Fall. There is no such broken order to re-establish ... The salient point is that he listened to someone other than God'.[16]

It's true. There is no mention at all of the man's having authority over the woman in the Garden! Read the story in Genesis chapter three.

Those are the five replies (in brief – he has a lot more to say on the matter) that Dr Sloane has assembled. These replies are eminently Biblical – back to the original language, and I would urge you to take them to heart. Dr Sloane's work is the product of his own rejection, based on the Word of God, of an entrenched patriarchal misunderstanding of what God is saying – and has said, through His Word.

The evidence is that each person is not only loved by God but also blessed, and of equal standing. Kidner calls it, 'Literally, a help opposite him (the man); i.e. corresponding to him'.[17] The man is overjoyed when at last he has a helper, in the form of a woman with whom he could communicate as another human. He exclaims 'This *at last* (my italics) is bone of my bones and flesh of my flesh ...!' (2:23). Humanity is complete. God's word is true: 'It is not good that man should be alone.' (2:18). 'Accordingly', writes Junia Poprifka, 'in the state of being "one flesh" there is no "shame" between woman and man in their nakedness, only an elation in being "one" with another.'[18]

16 Ibid., 166.

17 Kidner, Derek 'Genesis' in *Tyndale Commentaries* Donald Wiseman and Leon Morris eds, (Nottingham IVP 2008) CDROM

18 Junita Poprifka, 'Patriarchy, Biblical Authority and the Grand Narrative of the Old Testament' in *Tamar's Tears. Evangelical Engagements with Feminists Old Testament Hermeneutics*, ed. Andrew Sloane, (Pickwick Publications: Eugene, Oregon, 2012), 282-3, Kindle Edition.

Knight earlier dwelt on that same thought: 'The biblical picture of Adam and Eve ... implies what Martin Buber has taught us to call the 'I-thou' relationship between two equal persons. Yet in the biblical view two persons are one flesh (Gen. 2:24)'.[19] Martin Buber (1878-1965) was a famous Jewish theologian who wrote 'I and Thou' which became a classic. It's a brilliant book, full of amazing, deep insights. It's to do with the way humans relate to one another. The worst and lowest level that one can treat another is at the 'I-it' level, which means treating the other as an 'object' – an 'it', while the highest possible level is the 'I-Thou' level, which is to treat the other as of infinite worth. The implication is that Knight considers 'one flesh' to be even beyond 'I-Thou'.

Further thoughts of Sloane that truly reflect the Spirit of God: 'We are not called to foster patriarchal social systems as if they are the sovereign will of our Creator. They are not. Rather, they are signs of the brokenness of human sin and its disruptive effects, and we are called to combat that in all its manifestations'.[20]

<u>Some other thoughts</u>

Over my near half-century of ordained ministry, I've come across some really sad cases. Some males see it as their right to administer their brand of superiority with verbal bullying, or the knuckle, or worse, and some women seem to see that as the husband's 'right'. It's never right. To hit a defenceless woman is cowardly. It's outrageous. I recall making a pastoral visit to a woman at an Army married quarter and the first thing I noted was the swollen lip.

I suspected what had probably happened. 'What's with the lip?' I asked.

'Fred done it', she told me; 'but I deserved it – I answered back'. She didn't want me to interfere, in case it affected his promotion, she told me, so of course I couldn't.

19 Knight, George A.F. *A Christian Theology of the Old Testament* (London: SCM Press Ltd. 1964) 24.

20 Poprifka, 'Patriararchy' 169.

The trouble is, as with anything where sin is in control, the ride is always downhill. Some men who see their wife or partner as 'subordinate' cannot let it stop there, and the domination that follows, contrary to God's Word, occurs across every strata of society, including the ministry. In one parish where I was the minister, I was told that many years before (probably about sixty) an elderly, retired minister, his downtrodden little wife and their single daughter, started to attend that church. As it turned out, the minister was an autocrat. His wife and daughter always walked ahead. When they entered the church, the old minister would spy a pew he would like to sit in, so would hook his walking stick around his wife's *neck* (I was told) and guide her back. I found it hard to believe, but the session clerk, who'd been there since Moses was a lance corporal (as they say), assured me it was true.

A retired and elderly friend of ours, Dr John 'Sandy' Couston, who spent his career as a dentist, told me that up until about the end of the 1940's it was not uncommon for women to have all their teeth extracted before they were married, so as not to be a financial burden on their husbands.

I asked him if the men also had their teeth extracted for the same reason.

'No,' said Sandy, 'they didn't'. The needless extraction of sound teeth was so prevalent that dentistry, he told me, came to be known as 'a blood and vulcanite' profession. Vulcanite was the material used to make dentures before the advent of plastic. This story is nothing short of horrifying, to think that women should be so treated. It almost defies belief but Sandy assured me it's true. It also defies belief to think that the practice had, if not the approval, then at least the acquiescence, of society. Here is more evidence to suggest that women were regarded by and large as lesser creatures. As I remarked earlier, the possibility of abuse is much more likely where another is regarded in some way as not being equal and treated more as 'I-it' rather than 'I-thou'.

Where couples are married or in some form of partnership, it should be possible for them to live together in harmony, and lead normal lives, sharing responsibilities without serious conflict. It's much better if the union is based on a true, loving commitment to the other. It's even better when that commitment has a basis of religious faith, and promises made before God. All it takes is a preparedness to listen, to understand, and not to demand victories over the other. Vying for pole position (the need to 'win'), soon kills loving relationships. Paul sums it up very neatly in chapter 13:1-13 (the whole chapter) of his first letter to the Corinthians, sometimes called 'The Hymn of Love', which is frequently read at weddings. *Now I will show you the most excellent way*, he writes (verse 1) ... *Love is patient, love is kind...* Please read the chapter, even if you've read it before, and dwell on those words.

THE SEVEN PROPHETESSES OF ISRAEL

I am using the word 'prophetess' because the Hebrew language uses different words for male and female prophets. The word used for a female prophet (nabiah) translates as 'prophetess'[21] while the commonest word used for a male prophet is 'nabhi'.[22]

There are seven women in Judaism considered to be prophetesses: Miriam, Deborah, Hannah, Abigail, Sarah, Huldah, Esther but of the seven, Sarah, Hannah, Abigail, and Esther are not called prophetesses in the Hebrew Bible. Isaiah's wife was also named as a prophetess in the Bible, but only in Isaiah 8:3, so is not regarded as significant in the history of Israel. Another, Noadiah, is mentioned in Nehemiah 6:14 but that is the first and last mention of her.

So how did Sarah, Hannah, Abigail and Esther get to hold such distinguished titles? In Judaism, there are other books, apart from the Old Testament, that are considered authoritative. The most important of all is called The Talmud, which means 'that which is studied'.[23] The Talmud is a collection of ancient teachings, regarded as sacred, from earliest times, and many Jews regard it as sacred to this day. In the Talmud we learn that the Rabbis taught that our four ladies were declared to be prophetesses because of their outstanding lives and achievements. It was not so much that they prophesied, but because of the enormous impact they had for good, in the long history of Israel.

Another important document to help us in our understanding of the Old Testament attitude to women is called the Midrash (plural Midrashim) which is a 'Bible commentary, sermon in Scripture'. The Midrash is a collection of rabbinic expositions that interpret the Bible in order to bring out legal or moral truths.[24]. (Author's note:

21 W.E Vine, Merrill Unger, Merrill, William JR. White, *Vine's Complete Expository Dictionary of Old and New Testament Words*. (Nashville: Thomas Nelson, 1996), 191.

22 Ibid, 190.

23 Brad H. Young, *Meet the Rabbis – Rabbinic Thought and the Teachings of Jesus* (Grand Rapids Michigan: Baker Academic, 2010) , 86.

24 Ibid, 230.

The addition of 'im' at the end of a Jewish noun indicates plural. For instance, 'cherub' is singular, 'cherubim' is plural).

As we move on, and examine the lives of the seven, and refer at times back to the Talmud or Midrash, it will become clearer just why all seven are regarded so highly in Judaism. These remarkable women displayed Godliness, courage, initiative, prayerfulness, compassion. Their stories serve to inspire us all, in every generation, what it means to serve the Lord God with devotion, no matter how difficult our circumstance may be.

MIRIAM: PROPHETESS AND LEADER

The story of Miriam, contained in the Book of Exodus and mentioned in several places throughout the Old Testament, is a marvellous adventure story with a rather sad ending. Her story is linked inextricably to that of her brothers Aaron and Moses; all born in Egypt during the persecutions. The accepted order of the births is Miriam, Aaron and Moses, but we know nothing of the births of Miriam and Aaron.

Moses is the principal person in the Exodus story. Exodus 2:1 reads, *Now a man from the house of Levi went and married a Levite woman. The woman conceived and bore a son; and when she saw that he was a fine baby, she hid him three months.*

She had to hide him because Pharaoh, alarmed at the prolific numbers of Hebrews in Egypt, and fearing a rebellion, commenced a regime of persecution and terror. As well, to contain the numbers, he decreed that all male babies born to Hebrew women were to be killed. (Exodus 1:16).

After three months, when it became impossible to hide the child any longer, Moses' mother, Jochebed, made a basket from pitch and papyrus, placed the little boy in it and hid him among reeds along the river Nile. That's where Miriam comes in. It was she who stayed by the river bank to watch over her baby brother. (Exodus 2:3,4). Pharaoh's daughter came down to the river with her maidens to bathe, found the child, took pity on him and decided to keep him. Miriam cleverly asked Pharaoh's daughter if she would like a Hebrew woman to care for the baby. The princess agreed – and who was it that Miriam brought to her? Moses' own mother! (2:8,9). Already Miriam was displaying all the leadership qualities that one day would make her one of only three true prophetesses named in the Old Testament.

Years later, Moses led the Israelites out of Egypt in what is called the Exodus to the promised land – but he didn't do it alone. Miriam and Aaron, his sister and brother, were also leaders. Watching over

them, and the children of Israel, was God; their Guide and Saviour through the wilderness, to bring them at last to their home in Canaan.

I brought you out of Egypt
and redeemed you from the land of slavery.
I sent Moses to lead you,
also Aaron and Miriam. (Micah 6:4).

At God's direction, the Israelites fled Egypt, pursued by the Egyptian Army. Exodus chapter 14 describes the destruction of the Egyptian army as the Red Sea closed over them, but the Israelites miraculously passed through the waters. As the bodies of the Egyptian soldiers washed up on the shore, *Miriam, Aaron's sister, took a tambourine in her hand, and all the women went out after her with tambourines and with dancing* (Exodus 15:20).

Unfortunately, Aaron and Miriam, both senior in age to their brother Moses, challenged his leadership. It failed, and Miriam became the fall girl. She got the full blame, was punished and later died at Kadesh, and was buried there (Numbers 20:1).

There is so much more about Miriam's life in that other Jewish book called the Talmud, which contains a great deal of Jewish history.

Despite Miriam's sad end, let's not forget that she was a prophetess; the first prophetess named in Israel's great history, and a true leader of the people of Israel.

DEBORAH – WARRIOR PROPHETESS

(The Book of Judges chapter 4)

If you want to read of a feisty, warlike prophet in the Bible, take a look at our Debbie!

Before we get into the story itself, however, let's look at some of the fascinating background material of an event in the Bible that occurred over three thousand years ago, during the time of the Judges, in Israel.

We'll start with Deborah's name, which has much to say about her. For some reason, her name has evoked a deal of discussion over the years. 'Deborah' is translated from the Hebrew as D'vorah which means 'bee' but could also mean 'wasp'.[25] Marg Mowczko quotes Richard S. Hess who believes the name is derived from a Hebrew word, made up of the consonants DBR, which can mean 'lead' or 'pursue'. 'If Hess is correct, then the word *deborah* is fitting for the bee, and fitting for Deborah the judge, for the Canaanites were aggressively pursued and destroyed by the Israelites under Deborah's leadership'.[26]

Amazingly, two women feature in Judges, chapter four. The other is Jael, and as it turns out, she wasn't a lady to be messed with either.

Deborah in those days was a prophetess and also a judge, who judged the Israelites *under the palm of Deborah.* (Judges 4:5). What was 'the palm of Deborah?' Was it named simply because she sat under it to judge the Israelites? Some think so, but we don't really know. One commentator wrote that it 'may allude to the stateliness and gracefulness of women (Song of Solomon 7:7-8)'[27]: *You are stately as a palm tree* etc. Another suggestion is that it alludes to an

25 *The Jewish Encyclopedia,* '"Deborah," Accessed March 3, 2018 http://www.jewishencyclopedia.com/articles/5027-deborah

26 Marg Mowczko, 'What's in a name? Deborah, woman of Laippidoth', Blog, *Marg Mowczko: Exploring the biblical theology of Christian Egalitarianism,* 2015, accessed 1 April, 2018, https://margmowczko.com/deborah-woman-of-lappidoth/

27 Kenneth L. Barker and John R. Kohlenberger, *The Expositor's Bible Commentary: Old Testament.* (Grand Rapids, Michigan, 1994), 336.

oak near Bethel, where another Deborah, the nurse of Rebekah, was buried (Genesis 35:8). She had faithfully served the families of Isaac and Rebekah, Jacob and Rachel, for generations. When she died, she was buried at the foot of a tree, which they called Allon-bachuth: 'the oak of weeping'. Deborah, the faithful nurse – the only person in the Bible apart from the prophetess to have that name - must have been deeply loved.

That's a brief background. Our story commences with an account of the Israelites' oppression under the Canaanite ruler, Jabin, who had a powerful army and nine hundred iron chariots. For twenty years the Canaanite army, led by general Sisera had persecuted the Israelites. Now it was pay-back time. God spoke through Deborah: *She sent and summoned Barak, son of Abinoam from Kedesh in Naphtali, and said to him, 'The Lord, the God of Israel, commands you, 'Go, take position at Mount Tabor, bringing ten thousand from the tribe of Naphtali. I will draw out Sisera, the general of Jabin's army, to meet you ...'* (4:6,7a) Barak was one of Israel's generals. It could be argued that his response was a bit on the wimpish side. His reply was, *If you will go with me, I will go, but if you will not go with me, I will not go* (verse 8). I mean, he didn't exactly grab his sword and rush off, did he? I suppose it was understandable. As a soldier, he'd have seen the carnage that nine hundred iron chariots could inflict on infantry soldiers. Iron chariots in those days were high-tech and not available to the Israelites.

Deborah told him that she would go with him, but the downside was, she said, a woman was going to get the glory of polishing off Sisera, the Canaanite general.

Sisera rallied his nine hundred chariots and fighting men, expecting a push-over.

Then Deborah said to Barak, 'Up! For this is the day on which the Lord has given Sisera into your hand. The Lord is indeed going out before you' (4:14).

In a few short verses, it was all over. Sisera's army was destroyed, and Sisera was on the run. He managed to make it to the tent of a lady called Jael, who was married to a Kenite man called Heber. The Kenites and the Canaanites were on peaceful terms.

The unfortunate Sisera thought he'd be safe in Jael's tent. He got that badly wrong. Jael was a pragmatist. She realised that Sisera and his nine hundred chariots were done for, and soon the Israelites would be knocking on the tent door, looking for Sisera. She knew what would happen to her if the Israelites discovered that she was harbouring a fugitive. There was only one thing for it ... Jael threw open the tent door for the terrified general, who was heaving and puffing, hardly able to breathe, his armour, like his dream of victory, in tatters. We can almost hear the honeyed voice: 'Come in! Come in! Ooh - you poor darling – you look <u>awful</u>! Here – I'll get you some warm milk, and here's a warm rug. Lie down now and rest. You'll be fine, darl'. She gave Sisera the milk; the rug was warm, the tent cosy, and soon the exhausted general was sound asleep ... *Jael, wife of Heber, took a tent peg, and took a hammer in her hand, and went softly to him and drove the peg into his temple until it went down into the ground ... and he died* (4:21).

Shortly after, Barak came puffing up, brandishing his sword, looking for Sisera.

Again Jael threw back the tent door, mallet still in hand, and greeted Barak with a sweet smile. 'Were you looking for Sisera? D- dah! There he is!' She pointed to the skewered general.

The actual words of scripture don't say it quite like that: *Jael went out to meet him and said to him, 'Come, and I will show you the man whom you are seeking'. So he went into the tent; and there was Sisera lying dead, with the tent peg in his temple* (4:22).

There's an interesting little side issue here. Danna Nolan Fewell, writing the commentary of <u>The Book of Judges</u> chapter four in 'The Women's Bible Commentary', says that the tent peg was driven through

Sisera's mouth, not his temple. The word mistranslated as 'temple' is 'raqaq' which means 'parted lips.' She wrote that the peg driven through the mouth would have severed his spinal column, leaving him to die a convulsive death'.[28]

And so it was that Deborah's prophecy proved correct. Barak missed out on the glory of despatching his enemy, and it went to a woman.

All of chapter five is taken up with Deborah's song of triumph. What a leader!

Professor Scot McKnight writes that Deborah's *Schadenfreude* exceeded that of Miriam as she exulted in the defeat of Israel's enemies. 'Deborah was Ms EveryOne in those days: she was President, Pope and Rambo bundled in one female body'.[29] (*Schadenfreude* is a feeling of satisfaction one gets when seeing something unpleasant happen to someone else. I'd imagine this applies when reading a book or watching TV, to see the baddie come to grief: Sisera and Co. in this case). Deborah was the shining light all through the story and was obviously in control of the whole situation. Barak obviously was happy to acknowledge her as the leader and in fact the Jewish Encyclopedia comments: 'It is noticeable that Barak appears throughout as secondary to, and dependent upon, Deborah'. [30] One cannot argue about that, for it's true.

This story from the ancient Book of Judges is a remarkable testimony to the fact that God is quite happy to use women as the carriers of His Word. It is remarkable but it is not unique. Right through both Testaments we see that God is not at all concerned about gender. Male or female, our Creator Who made each one of us, uses us when we are open to the promptings of the Holy Spirit. In this story, each goes about the task God appointed.

28 Newsom and Ringe, *The Women's Bible Commentary*, 69.

29 McKnight, Scot, *Junia Is Not Alone* (Englewood, CO.: Patheos Press, 2013) Kindle edition .

30 The Jewish Encyclopedia. *Judges.* http://www.jewishencyclopedia.com

That fact is demonstrated, not only through the pages of the scriptures but down through history itself; in the early church and beyond. Joan of Arc for instance rode before the French army to lead it to victory.

Looking back on our story, we can see that Barak, although a mighty general, had enough humility to give place to a woman, at a time when it was a rarity indeed, for he saw and acknowledged, that God had blessed her with special gifts. She was the principal person. Right at the beginning, in chapter four, Deborah *summoned* Barak. He came, helmet in hand.

One of the objections I've heard is 'Yeah – but at the time, there were no suitable men. God had to choose a woman!' It's a naïve argument. God doesn't *have* to do anything of the sort. Had God decided that it was a job for a man, that man would have been given the gifts necessary for the task. There can be no 'yeah buts' about it.

............................

One evening in Jerusalem, about thirteen centuries after our dramatic story from the Book of Judges, a man named Nicodemus met Jesus, where they discussed religious matters (John 3:1-21). Nicodemus was on a big learning curve. Jesus described how the Spirit of God can be likened to the wind in the trees and grass, which comes and goes as it wills. So it is with the Spirit. *The wind blows where it chooses, and you hear the sound of it, but you do not know where it comes from or where it goes. So it is with everyone who is born of the Spirit.* (John 3:8). It's a great play on words. 'Wind' and 'spirit' **πνεύματος** (pneumatos) is the same word in Greek. No one can change the direction of the wind from an east wind to a west wind. No one can limit the work of the Holy Spirit. The Spirit is free.

Take note of that word, 'everyone' (who is born of the Spirit). The Greek word used here for 'everyone' is πᾶς (pas) and it means quite literally, 'everyone'. Just as God spoke to Deborah, so God speaks to us all. Let's be open to the prompting of the Holy Spirit.

If you feel that God has a task, to pray about it. Be proactive. If God is calling a person to a task, that person will be given the strength and all that is needed to accomplish it. That does not necessarily mean it will be easy. It's a challenge. It's happened countless times in the past, is still happening and will continue to happen.

Let's keep heart and mind open to whatever the Holy Spirit may be calling us.

HANNAH – THE PRAYERFUL MOTHER OF SAMUEL

When we turn to the First Book of Samuel, we note that the first one and a half chapters are devoted to this remarkable lady, Hannah, one of Elkanah's two wives.

Elkanah's first wife, Penninah, bore him a number of children, but Hannah, like Abram's wife Sarai centuries before her, was barren. Elkanah's first wife, (we'll call her Penny for short), sad to say, made Hannah's life a misery by reminding her continuously of her barrenness: *Her rival used to provoke her severely, to irritate her, because the Lord had closed her womb ... Therefore Hannah wept and would not eat* (1 Sam 1:7,8b). Ultimately, who was responsible for Penny's hissy fits? Elkanah – none other! Yes – he, the husband, was the guilty one – because he played favourites. He made it plain that he loved Hannah more than Penny. He used to give her double portions at the sacrifices (v.5) and doubtless made it plain in other ways who was his favourite. It's a good case for never showing favouritism. We can well understand Penny's resentment. Too bad she didn't take it out on her husband, or at least reason with him, but in that male dominated society, it may not have been a good idea.

Unlike Penny, Hannah had a soft and gentle spirit. Penny's scorn simply brought her unhappiness and tears; not resentment. She longed for a child of her own and prayed incessantly to God that she might be granted the wonderful gift of motherhood.

One day, Hannah prayed silently in the temple and made a vow: *O Lord of hosts, if only You will look on the misery of Your servant, and remember me, and not forget your servant, but will give Your servant a male child, then I will set him before You as a nazirite[31] until the*

31 Nazirites were 'devoted' to the Lord for a set period of time and were prohibited from drinking alcohol or eating grapes, cutting their hair or beards, and approaching a dead body. Extracted from *the NRSV, The New Annotated Oxford Bible, Third Edition*, Ed. Michael Coogan (New York, Oxford University Press 1989)

day of his death. He shall drink neither wine nor intoxicants, and no razor shall touch his head.(1:11).

Eli, the temple priest, also prayed on her behalf and in time, as with Abraham's wife Sarai centuries before, there was a miracle: Hannah gave birth to Samuel, which means, *I have asked him of the Lord.* (1:20b). Samuel of course grew up to become one of the truly great prophets of Israel.

Now we come to the interesting fact that Hannah's name does not appear in the Old Testament as a prophetess, but nonetheless is so regarded in Judaism.

She is called a prophetess because 'Hannah prayed and said, *My heart exults in the Lord, my strength (literally, "my horn")[32] is exalted in my God. My mouth derides my enemies, because I rejoice in my victory.*'

The ancient Jewish rabbis said that because she said *my horn is exalted*', and not, *my cruse (*literally, a dish, a water container*) is exalted*', she implied that the reigns of the houses of David and Solomon, who were anointed with oil from a horn, would be prolonged, but the reigns of the house of Saul and Jehu, who were anointed with oil from a cruse, would not be prolonged. To us, that may seem a bit on the tentative side, but she did prophecy:

The LORD! His adversaries shall be shattered;
the most High will thunder in heaven.
the Lord will judge the ends of the earth.
He will give strength to His king,
and exalt the power of the anointed. (2:10).

That was a prophecy that was to become true. Ahead lay the first kings of Israel; Saul, then David, and both triumphed over the enemies of Israel. *He will give strength to His king.*

32 The horn in ancient times was a musical instrument; also a symbol of strength: ram's horn, bull's horn; also used to carry oil to anoint.

Hannah prophesied of a king, years before there was a king in Israel. Samuel her son anointed Saul from a vial and David and Solomon from a horn. She was a true prophet.

Perhaps Hannah's most appealing virtues are her boundless faith in God, when most would have given up hope of ever having a child; her tenacity and her humility. She was a woman of prayer. In the Hebrew, she would have been called a tzaddik: 'Often people call someone a tzaddik simply because he is an exceptionally good person. Then there are times they come across a spiritual superhero, someone more like an angel than a human being, and they say, "Now that's a tzaddik!"'[33] That's Hannah.

We know only too well that it doesn't always work out the way we hoped and prayed. In the end, we have to remember that God always knows best. In God's good time, Hannah conceived – but not always do our prayers have the answers we want. In one of my parishes many years ago, a lady who had several boys badly wanted a girl. When she conceived again, she and her friends held weekly prayer meetings and at last, when she was about six months' pregnant, she felt she'd been given an answer!

One day I sat having a cup of tea with her at her house. 'It's wonderful!' she enthused; 'My friends and I had the same message – it's going to be a girl!'

About three months later, I baptised little Caleb for the happy but chastened mother and beaming father. It had been a case of wishful thinking.

More years passed and I lost contact with the family, for we'd moved a couple of times. One day I had a phone call. It was Caleb's mother, catching up. Her husband had died – and the one who had

33 Tzvi Freeman, 'What is Tzaddik?' *Chabad.org,* accessed March 20, 2018, https://www.chabad.org/library/article_cdo/aid/2367724/jewish/Tzaddik.htm

become her mainstay and help was Caleb. He'd been to university, had a good job, was bright and outgoing, and was a devoted son.

'He's such a marvellous son', she told me; 'God always knows best.'

We know there are not always happy endings like that one, and all we can do is trust God, Who knows the end from the beginning. The story of Job is a good example. After a series of appalling tragedies, in which Job's faith remained strong, his exasperated wife yelled,

Do you still persist in your integrity? Curse God and die!

But he said to her, 'Shall we receive the good from God and not the bad?

In all this, Job did not sin with his lips. (Job 2:9,10)

Such was Hannah's faith.

ABIGAIL AND DAVID – A BEAUTIFUL LOVE STORY

According to Rabbinical literature, Abigail was one of the most remarkable women in Jewish history. She is also believed to have been one of the most beautiful; a virtue she shares with Sarah, Rahab and Esther.[34] Her name appears in the Talmud.

First, let's hear about Abigail from a Jewish academic: 'Although the Bible does not depict her as such, Abigail's entreaty to David in I Sam. 25:24–31, which forecasts his military victory over his enemies and his future as king over Israel, was perceived as a prophecy. Since she was blessed with divine inspiration, the Rabbis learned of the afterlife from what Abigail pronounced. She told David (v. 29): "the life of my lord will be bound up in the bundle of life," from which the Rabbis derive that God bundles up the souls of the righteous with pleasure and honour.'[35]

The story of the first meeting, and finally the marriage of Abigail and David is contained in 1 Samuel 25.

Like Moses all those centuries previously, David was on the run. He was fleeing the wrath of King Saul, who was eager to kill him, for no more reason than the fact that David was so much more popular than Saul, who feared that David would end up on his throne. (He was right about that one!) David was the darling of the people. He had not long killed Goliath, the giant Philistine. Afterwards, on their way home after David's triumph over Goliath ... *the women came out of the towns of Israel, singing and dancing, to meet King Saul, with tambourines, with songs of joy, and with musical instruments. And the women sang to one another as they made merry, Saul has killed his thousands, and David his tens of thousands.*

34 Tamar Kadari, "Abigail: Midrash and Aggadah," *Jewish Women's Archive Encyclopedia*, accessed March 28, 2018, https://jwa.org/encyclopedia/article/abigail-midrash-and-aggadah

35 Ibid.

Saul was very angry, for the saying displeased him. 'They have ascribed to David ten thousands, and to me they have ascribed thousands; what more can he have but the kingdom?' So Saul eyed David from that day on. (1 Samuel 18:6-9). The situation between the king and David continued to deteriorate, until finally David fled for his life. For the next few chapters, we read of the manhunt, with David always one step in ahead of the king. Fortunately David had allies, and several hundred loyal troops who travelled with him.

Of course 'an army marches on its stomach', goes the saying. Soldiers must eat. David and his men frequently protected farming properties on a voluntary basis from thieves, and for that, grateful farmers gave David supplies. One of those whose property they protected was Nabal, a very wealthy, but drunken farmer, known by all and sundry, including his wife Abigail, as a nasty piece of work.

One day David heard that Nabal was shearing sheep, and as he had protected Nabal's property, he thought it appropriate to have some of his men ask the farmer politely for some supplies. Nabal scornfully rejected the request, and when his men reported this back to David, it upset him no end.

'Right! If that's the way he wants it, buckle up, boys! We're going to sort out this Nabal turkey!' The Bible actually puts it, *David said to his men, 'every man strap on his sword!' And every one of them strapped on his sword; David also strapped on his sword* (25:13). He and four hundred men went to sort out Nabal.

Meanwhile, Abigail, Nabal's beautiful wife, heard that David was coming, seeking vengeance, so rushed out to intervene. She met David as he approached and pleaded with him to desist. She certainly knew what her husband was like.

She said, *My Lord, do not take seriously this ill-natured fellow, Nabal ... Nabal is his name, and folly is with him ...* (25:25). She had brought a lot of food for David and his troops as a peace offering. Then she prophesied, *The Lord will certainly make my lord a sure house,*

because my lord is fighting the battles of the Lord, and evil shall not be found in you as long as you live. If anyone should rise up to pursue you and to seek your life, the life of my lord shall be bound in the bundle of the living, but the lives of your enemies He shall sling out as from the hollow of a sling ... (1 Samuel 25:28,29). There is a lot more that you may care to read, but she finished by saying, *And when the Lord has dealt well with my lord, then remember your servant.* (verse 31). Those words are particularly significant, as you will see.

One flutter of long dark eyelashes, one pleading gaze from those 'beautiful, beautiful brown eyes' (a song), one slender caress of his arm, and David was hooked!

He replied, *Blessed be the Lord, the God of Israel, Who sent you to meet me today*! (verse 32). It was love at first sight – certainly on David's part.

Abigail departed, doubtless watched yearningly by the love-sick David as her donkey took her around a bend in the path and out of sight.

Abigail went home to tell Nabal her husband, who was hosting a drunken party that night, so she waited until morning to break the news. Immediately he had what seems to be a stroke or heart attack, and about ten days later he died. There is some suggestion that when he realised how close he was to losing his head that night, he had a seizure. Abigail probably told him what David had told her: 'If you hadn't come to restrain me, not one male in Nabal's house would be alive'. (Verse 32). *Then David sent and wooed Abigail, to make her his wife.* (verse 39b). Not long after, they were married.

There is no doubt that Abigail, beautiful and smart, also had plans of her own. That is what the ancient Rabbis believed. The following is a passage from the Jewish Women's Archive:

Before taking her leave of David, Abigail told him (v. 31): 'And when the Lord has prospered my lord, remember your maid'. The Rabbis responded to this with a popular saying: 'While a woman talks she spins,' which praises a woman's ability to engage simultaneously

in two activities that require one's attention. Abigail was indeed blessed with this trait, characteristic of women, the Rabbis believed. She engaged in her husband's affairs and tried to save his life, while at the same time she wisely laid the foundation for the future, by asking that David favourably remember her for her actions. Some Rabbis apply another proverb to this: 'The goose stoops as it goes along, but its eyes gaze afar.' This saying describes the nature of the goose to forage for food on the ground with stooped head, but at the same time its eyes, located on the sides of its head, look around to ensure that no danger lurks. Thus Abigail engaged in the immediate concern (saving her family from David's sword), while at the same time looking into the future and preparing her household accordingly'.[36]

There can be no doubt about it, the romance was genuine and David loved Abigail, and she loved him. Abigail showed an amazing capacity to size up a potentially very dangerous situation and use her initiative and leadership skills – her brains and her beauty wisely and well, in an age where women did not have many rights.

Reflecting on this remarkable story, it seems that from the very beginning of her meeting with David, Abigail was in control. She made all the appropriate gestures of subordination expected in those days: *When Abigail saw David, she hurried and alighted from the donkey, and fell before David on her face, bowing to the ground* (25:23). Yet all the time, she was in control of the situation. Here was Abigail, talking and spinning. Skilfully she used all her abilities, as good leaders do, using what they have for successful leadership, from training and education to personality, applying what the situation called for. David unknowingly was led all the way by the brilliant Abigail to achieve the outcome she wanted, including marriage to the future king of Israel. She deserves to be numbered by the Rabbis among the prophetesses. Well done, Abigail!

36 Ibid.

SARAH – MOTHER OF NATIONS

The story of Sarah is a long one, for she was one hundred and twenty-seven years old when she died – and I have to smile, for the Midrash tells us that she died prematurely!

Her death was possibly brought on by the shock of nearly losing her son Isaac, when God tested Abraham by telling him to sacrifice their boy. It was only to test Abraham's loyalty and God stopped the sacrifice before it happened. No wonder Sarah was so devastated – she was 90 years of age when she gave birth to him!

Sarah is rightly revered in Judaism. She was the first of the four matriarchs. A matriarch is one married to a patriarch, of which there were only three: Abraham (married to Sarah); Isaac (married to Rebekah) and Jacob (married to Leah and Rachel).

When Sarah and Abraham married, their names were slightly different. Sarah was Sarai and Abraham was Abram. Sarai was ten years younger than Abram – and he was her uncle as well as her half-brother! She was the daughter of Abram's father, but not the daughter of his mother (Genesis 20:12). Apparently such unions were not uncommon in the Ancient Near East. So let's go back now, and trace the story of Sarai and Abram, 'way back in a dim and distant past. It certainly was a long and at times dangerous journey. Because Sarah's story is a long one, and we are not doing a biography of her, it may be necessary to trace her story in snapshots. As well, we may include the odd interesting little snippet from the Midrash or Talmud.

We know nothing of Abraham's and Sarah's earlier lives. Genesis 11:29, simply said that Abram and Nahor (his brother) 'took wives' and in verse 30 that Sarai was barren.

Genesis 12:1-3: God spoke to Abram: *I will make of you a great nation, and I will bless you, and make your name great, and you will be a blessing. I will bless those who bless you, and the one who curses you, I will curse; and in you all the families of the earth shall*

be blessed'. That promise is repeated in 13:14-17. It was an age where women were held in small account; especially if barren, so Sarah does not get a mention here. The fact is, however, she was inextricably part of the promise, for it was she who eventually was to bear a child.

Abraham and Sarah moved to Egypt because of a great famine. Near the border, Abraham, knowing that Sarah was extraordinarily beautiful, suspected that Pharaoh would soon learn of her beauty and want her for his harem. Abraham feared that Pharaoh would simply dispose of him and claim Sarah, so he told his wife to let it be known that she was his sister, not his wife. (Am I mistaken here, or is there a sudden doubt on Abraham's part that God would keep His promise?) Anyway, Sarah went along with it. Pharaoh claimed her but God made things so difficult for the king that he was happy to be rid of her. According to the Midrash, Pharaoh couldn't even get near Sarah when she was in his palace. The Lord started knocking him about! He gave her back, together with much wealth and sent the couple on their way. Abraham became very rich!

A Jewish writer has an interesting comment here: 'Although the wife-sister stories are difficult to understand, the fact that Sarah becomes a slave in Pharaoh's house serves to foreshadow Israel's later bondage in Egypt. She herself is not in danger of her life – but the reader knows that nascent Israel is in danger of losing its ancestress. And so God acts to protect Sarah by afflicting 'Pharaoh and his house with great plagues' (Gen 12:17) until he realizes the problem and sends Sarah away. Protection and plague foreshadow Israel's later redemption at the exodus.'[37]

Through the chapters that follow, there is a resounding silence when it comes to any reference to Sarah's name. It's all to do with Abraham. God said, *No longer shall your name be Abram, but your name shall be Abraham, for I have made you the ancestor of a mul-*

titude of nations. (Genesis 17:5). Then God said to Abraham, *As for Sarai your wife, you shall not call her Sarai, but Sarah shall be her name. I will bless her, and moreover I will give you a son by her. I will bless her, and she shall give rise to nations; kings of people shall come from her.* (Genesis 17:15,16). It has taken so long for Sarah to be recognised and her name changed to Sarah.

Sarah eventually bore her son, Isaac: *The Lord dealt with Sarah as He had said, and the Lord did for Sarah as He had promised. Sarah conceived and bore Abraham a son in his old age, at the time of which God had spoken to him.* (Genesis 21:1,2).

The Rabbis held the beautiful and godly Sarah in special reverence. She was also one of the wisest, so let's go to other, ancient books of scripture to look a little closer at her background that earned her the title of Prophetess.

SARAH in Rabbinical Literature

'Sarah was the niece of Abraham, being the daughter of his brother Haran ... She was so beautiful that all other persons seemed apes in comparison. Even the hardships of her journey with Abraham did not affect her beauty (Gen. R. xi. 4). She was superior to Abraham in the gift of prophecy. She was the 'crown' of her husband; and he obeyed her words because he recognized this superiority on her part. She was the only woman whom God deemed worthy to be addressed by Him directly, all the other prophetesses receiving their revelations through angels'.[38]

It's only natural that we should also look at what the Jewish Women's Archive has to say about her: 'Sarah, the first of the four Matriarchs, has come to symbolize motherhood for the entire world, and not only for the people of Israel. The Midrash presents her as a prophet and a righteous woman whose actions are worthy of emulation; she

38 Hirsch, Emil G. Wilhelm Bacher, Jacob Zallel Lauterbach, Joseph Jacobs, Mary W. Montgomery. "Sarah" The Jewish Encyclopedia, accessed 20 Februrary 2018, http://www.jewishencyclopedia.com/articles/13194-sarah-sarai

converted Gentiles and drew them into the bosom of Judaism. The changing of her name from Sarai was her reward for her good deeds, and attests to her designation as a *Sarah* (i.e., one of the ruling ones); not only for her own people, but for all the peoples of the world ... Sarah is described as preeminent in the household. Abraham was ennobled through her, and subordinated himself to her; God commanded him to heed his wife, because of her prophetic power. The different traditions tell of Sarah's role in spreading the name of God throughout the world. Her maternity expanded and came to symbolize the warm bosom of Judaism, both for her future descendants and for all the world'.[39]

It's from the Midrash and other related books that we get a clearer picture of Sarah, the 'mother of nations'. Abraham's name means 'Father of Multitudes' and so it turned out to be. Sarah's name means 'The Princess'. What an amazing woman! She was probably married in her teens, then had to wait until she was ninety to have her child Isaac. Through it all she endured untold hardships; even being given by her husband to an Egyptian pharaoh. In all those many years, she grew wiser as adventure followed adventure. Only once did her faith waver, and that's when finally she started to doubt that God would bless her with a child, so told Abraham to have a child through her Egyptian slave girl, Hagar, which ended up causing all sorts of problems. (Genesis 16 – the whole chapter). Abraham's moment of doubt is mentioned earlier. It goes to prove they were both human. It is through the Rabbinic writings and the Jewish Women's Archive that we learn that Abraham was wise enough to defer to his beautiful, wise wife. Tikva Frymer-Kensky writes, 'Having secured Isaac's position in the family, Sarah disappears from Genesis. She plays no role in the near sacrifice of Isaac. She dies at the age of 127 in Hebron (Gen 23:1-2). Abraham buys his first real property in the land of Israel, the Cave

39 Tamar Kadari "Sarah: Midrash and Aggadah" *Jewish Women's Archive Encyclopedia*, accessed March 28, 2018, https://jwa.org/encyclopedia/article/sarah-midrash-and-aggadah

of Machpelah, in order to bury her (Gen 23:19). She is mentioned three more times in the Book of Genesis (24:36; 25:10-12). She is remembered in the prophecies of Isaiah 51 (v.2) as the ancestress of her people'.[40]

In the holy scriptures, as well in the Jewish writings, Sarah stands tall. Isaiah mentions her faith in Isaiah 51:2. Paul mentions both Sarah and Abraham among those whose faith was counted unto righteousness (Romans 4:19) and Paul writes, *This means it is not the children of the flesh who are the children of God, but the children of the promise are counted as descendants. For this is what the promise said, 'About this time I will return and Sarah shall have a son'.* (Romans 9:8,9).

How worthy she is of the title, 'prophetess'!

40 Frymer-Kensky, " Sarah/Sarai: Bible"

ESTHER - BORN TO BE QUEEN

A story of kings and queens, harems and virgins and dark intrigues

If you're looking for a tale of mystery and suspense ... dark dealings and dark deeds in dark places; 'dirty work at the crossroads'; sinister dealings; good guy, bad guy and beautiful women, then you need look no further than the Book of Esther. This is a top mystery tale that takes place in exotic Persia, somewhere between 486 and 465 BCE.

Our story opens in the palace of the king, Ahasuerus, (believed by most scholars to be Xerxes 1), who was throwing a massive banquet for all his ministers and officials and high-up yes-men and hangers-on. All the nobles and governors were there, as well as representatives of the Army. It was some show, and it was a great opportunity for Ahasuerus to show off his fabulous wealth. This wasn't some overnight 'bash' with all the drunks leaving in the wee small hours, to be driven home in their Cadillac and Rolls Royce carriages. This was a full-scale booze-up – and it went on *for six months*. (Esther 1:4b).

All good things come to an end and finally it was over. Ahasuerus, still in good spirits and possibly wanting to prove he was one of the boys, decided to give a seven-day booze-up to the boys in the citadel (the soldiers in the fort guarding the city). Once again the good crockery was brought forth: *Drinks were served in golden goblets, goblets of different kinds, and the royal wine was lavished according to the bounty of the king. Drinking was by flagons, without restraint; for the king had given orders to all the officials of his palace to do as each one desired.* (Esther 1:7,8).

Meanwhile Vashti, Ahasuerus's gorgeously beautiful queen, was treating the ladies to a banquet back at the palace. At the end of the seven-day fling, Ahasuerus, who had been boasting how beautiful his wife was to anyone who would listen, sent for her to prove it.

Vashti, who was probably lying down with a headache, having already taken a couple of headache powders, washed down with a

good cup of tea, refused to go. The very thought of getting out of her nightie and into the 'glad rags' and putting on the lippy and rouge, false eyelashes and mascara, was just too much. When the eunuchs reported back that the queen had refused to obey, Ahasuerus could hardly believe his ears, and he 'did the block'. I mean, we're dealing with a slightly unstable character here. His father had been king before him and dad's little boy didn't like to hear the word 'no'. Vashti took her life in her hands in refusing to obey him, for her husband was definitely unstable. To digress for a moment, to give an example of his unstable temperament: Under his other name as Xerxes 1, his army at one time attacked Greece. A sudden storm destroyed two boat bridges he'd built to cross the Hellespont, and Xerxes (aka Ahasuerus) had the sea given three hundred lashes as punishment, to teach it a lesson it would never forget. According to legend, he also threw in a set of shackles, but I doubt if the sea gave a toss ... maybe threw him an indifferent wave.

Back to the palace: When word came of Queen Vashti's rebellion, her husband's rage knew no bounds: 'Out!' he screamed; 'You're finished! Never darken the doors of this palace again!' Read the whole sad story in Esther 1:12-22). That was followed by an official order: *All women will give honour to their husbands, high and low alike.* (1:20b). Yes - Ahasuerus's mental plug had come a little adrift from the wall-socket.

Now the king had to start looking around for a new queen. His servants had a sudden rush of blood to the brain: '*Let beautiful young virgins be sought out for the king. And let the king appoint commissioners in all the provinces of his kingdom to gather all the beautiful young virgins to the harem in the citadel of Susa under the custody of Hegai, the king's eunuch ... and let the girl who pleases the king be queen instead of Vashti'. This pleased the king, and he did so.* (2:2-4).

Enter Mordecai, a Jew in the citadel of Susa. He and hundreds of fellow Jews had been led away as slaves, after Jerusalem had been laid waste by king Nebuchadnezzar. Mordecai had a young cousin; an

orphan named Hadassah (Persian name, Esther) who was unusually beautiful. Mordecai had adopted her as his own daughter. When all the beautiful young women were gathered up for inspection by the king, Esther was among them.

Mordecai had charged Esther not to tell anyone she was Jewish. He kept a surreptitious and loving eye on his adopted daughter during all those procedures. To cut a long story short, the king became besotted with Esther: ... *the king loved Esther more than all the other women ... so he set the royal crown on her head and made her queen instead of Vashti* (2:17). Imagine it – from foreigner living in a pagan land, and a child of slaves at that, to being made queen of a great empire! No more cappuccinos in cardboard takeaways for that girl! That should have been the end of the story. As queen, with unimagined power, Esther should have been able to look after her Jewish people and protect them – but it was not to be.

Enter the villain: Haman, highest official in the land who was very much aware of his own importance, and arrogant with it. When he entered the king's gate, all the king's servants touched the forelocks, bowed, scraped and carried on – except Mordecai. That made Haman very angry, for he was a vain man. When he discovered that Mordecai was a Jew, he decided to rid the lands under Persian control of all Jews. In secret, he gathered his henchmen around him to talk it over. We can imagine them, late one night, in an unobtrusive house, set back in an unobtrusive street, seated around a table, candles dimly burning, a bottle or two of good Persian reds on the table, discussing ways and means of implementing their evil scheme. There must have been a bit of a disagreement about a suitable date for the operation to begin, so they ended up casting lots: 'pur' (3:7). A pur is a 'lot'. The day chosen was *the thirteenth day of the month of Adar* (3:7) (roughly 13 March). As I read that I was reminded of others – Roman soldiers, centuries later, who after they had crucified Jesus, 'cast lots' for His clothes (Matthew 27:35).

The die was cast. Evil Haman, intent on mass murder, went to see the king and managed to spin him a heap of lies and half-truths, and finally convinced Ahasuerus that a potentially dangerous enemy, in the form of the Jews, lurked among his people; not only in the city of Susa but right across the empire. The king signed the papers and the stage was set: On the 13th day of the month of Adar the massacre would begin.

'We'll rid the empire of the lot of 'em, young and old alike', Haman said happily.

'I'll drink to that', Ahasuerus replied, raising his golden goblet. (3:12-15).

Mordecai got the news of the coming massacre and was overcome with grief and dismay. He wrapped himself in sackcloth and ashes and went through the city, wailing and weeping. As word spread, most of the Jews donned sackcloth and ashes and lay about the place, waiting for the end.

Enter Esther. You may have been wondering when Queen Esther would make her grand entrance into the story. Here she is. She had probably been swanning about the palace, showing off her new wardrobe to her admiring attendant maidens, in complete ignorance of the whole developing situation.

When she got the news, she didn't lose her nerve, the way Mordecai did. She started at once to take control of the situation. She sent her minder, Hathach the eunuch, to go to Mordecai and find out everything that had happened – including the news that Haman would pay ten thousand talents of silver to the one who was prepared to organise the massacre. She jollied her father Mordecai along a bit, and he rallied. Between them they organised a dangerous counter move – which would be at the risk of Esther's life. She had Mordecai call all the Jews he could to fast for three nights and days. She and her maidens would do the same. She prepared herself to go to the inner court of the palace without being announced. The law said that anyone – even

the queen - who went to the inner court without being announced would be killed at once. Only if the king held out his sceptre, may that person live.

Esther said, *'After the fasting I will go to the king, though it is against the law; and if I perish, I perish'. Mordecai then went out and did everything Esther had ordered him.* (4:16,17).

The king, you may recall, was a man of unpredictable temperament, so it was a dangerous exercise for Esther – but he must have had a good breakfast that day, for when Esther appeared at the door unannounced, he held out the sceptre to her (Sighs of relief!). As they chatted, she asked her husband to arrange a banquet and to include Haman as a guest, to which the king happily agreed. He liked banquets, as we learned earlier. Esther told him she would have a petition for him to consider.

Came the day of the banquet. It was a cosy scene. The king, Haman and Esther sat chatting away until the king asked *'What is your petition, Queen Esther? It shall be granted you, even to half of my kingdom, it shall be fulfilled'.* (7:2)

Esther told it like it was – she and all her people faced death because of the wicked lies of a certain individual.

'And who is this certain individual?' asked the king, his neck growing red.

'He's sitting right beside you, darling – it's Haman! He's as bent as a fish hook!'

'WHAT?' The king's face and neck had gone dark, blotchy red, as his eyes swung to his now terrified senior official.

Haman started to blubber and carry on, but it was no use. The king ordered him to be hanged from the very gallows he'd had built for Mordecai, and so Haman, apparently untouchable at one time as a favourite of the king, dangled high for his misdeeds ... what we might call poetic justice. He wasn't the only one. Esther got to work and

ordered all those across the empire who had sought the massacre of the Jews, put to death. The undertakers did a roaring trade for months.

Not only that; Esther had her father Mordecai raised to a top-ranking position in the government: *Then Mordecai went out from the presence of the king, wearing royal robes of blue and white, with a great golden crown, and a mantle of fine linen and purple, while the city of Susa shouted and rejoiced* (8:15).

This is a great story of good triumphing over evil, and in the end it was because Esther was prepared to take control of a desperate situation. Braving death she won out, because she outwitted her arch-enemies. Her original Hebrew name was 'Hadassah' (myrtle), while that of 'Esther' derived, according to some authorities, from the Persian 'stara' (star).[41] There's no doubt about it – she *was* a star! Well does she deserve the title of prophetess!

One more thing: The Jewish feast of Purim (pur-im, plural of pur - casting lots) dates from that very time, when the enemies of the Jews were planning evil against them. It's held about a month before Passover. Purim is a joyous celebration, still held each year as the Jewish people remember Esther, and their deliverance from the hands of their enemies, and give thanks to Adonai: God.

41 Hirsch, Prince, Schecter "Sarah"

HULDAH – GODLY PROPHETESS IN AN AGE OF GODLESSNESS

Huldah's story comes to us from a very difficult time in the history of Israel. The people had drifted into apostasy and idolatry on an unprecedented level. Their kings had been instrumental in leading them down that path.

Huldah lived during the time when Josiah came to the throne as an eight-year old king. His early enthronement was due to the fact that his father, King Amon, had been murdered. Both Amon, and Amon's father, King Manasseh, wantonly abandoned the God of Abraham, Isaac and Jacob, and walked in the ways of wickedness. They worshipped at pagan shrines, followed witchcraft and spilt much innocent blood. It was a very bad time for Israel.

By a miraculous turn-around, little Josiah, from the very beginning, walked in the way of the Lord. (2 Kings 22:1,2). When he'd been reigning for eight years (at age sixteen) he renounced the evil ways of his father and grandfather. He wanted to return the people to the paths of righteousness. He instituted what has come to be known as 'Josiah's Reforms' and destroyed every vestige of anything to do with heathen worship - everything that was an abomination to the Lord, and ordered the people to return to the Lord their God, and to keep the Passover (23:21).

In the eighteenth year of Josiah's reign, the High Priest, Hilkiah, discovered the Book of the Law in the House of the Lord, during some repair work that was going on. Stephan the secretary read the book to Josiah. *When the king heard the words of the book of the law, he tore his clothes* (2 Kings 22:11). The king sent Hilkiah and a few others to find out what the book meant – and they went to consult Huldah, the prophetess. She confirmed that the book of the law was genuine: a message of doom for Judah: *Thus says the Lord, I will indeed bring disaster on this place and on its inhabitants – all the words of the book that the king of Judah has read* (2 Kings 22:16). She also prophesied

that Josiah would be taken before the end came, so that he would not have to endure the horror that was to befall the nation, because he humbled himself before the Lord his God. (22:18-20).

Some have questioned why Hilkiah and the others went to consult Huldah and not a male prophet. Jeremiah, for instance, was prophesying at the time, warning the people to mend their ways. Zephaniah was also prophesying in those years. Hilkiah could have gone to either of them – but he went to Huldah. There is only one answer that I can think of: First, her godliness, and second, the accuracy of her prophecies. She was very well known, and was looked upon with awe and reverence. If Hilkiah, the high priest; a man of considerable power and influence, had complete faith in her, then it was no wonder it was she who was consulted. Her prophecy turned out to be accurate. King Josiah was killed in the battle at Megiddo against the Egyptians and not long after, Judah fell to the Babylonians.

Claudia V. Camp writes: 'It appears that ... that prophecy was one religious vocation open on an equal basis with men. Certainly the narrator of Kings takes no notice whatsoever of Huldah's gender ... (Huldah's) words of judgement are centred on a written document as no others have been before her ... it takes a prophet to actualise its words in history, to set its truth in motion. This woman thus not only interprets but also authorises the first document that will become the core of scripture for Judaism and Christianity'.[42]

42 Claudia V Camp, '1 and 2 Kings', *The Women's Bible Commentary*, Carol A Newsome and Sharon H Ring, eds, (London: SPCK, 1992) 109

RUTH – A STORY OF FAITHFULNESS

Ruth is not called a prophetess in the Hebrew Bible, but her life is so important in the history of Israel, and later the birth of Jesus, that she deserves to be mentioned. Here she is.

The story of Ruth is encompassed in four short chapters, which the NRSV in its introduction describes as 'four chapters of elegant Hebrew prose'.[43] It is a beautiful story, apart from the initial sadness, so let's see what it has to say.

The story takes place in the time of the Judges, so-called because in those days Israel had no king. Temporal leaders called judges ruled the land. This lovely story had ramifications for the future, in the mysterious ways that God has of planning things.

A great famine had settled on Judah (probably in the form of a massive drought) and one little family decided enough was enough. Elimelech, his wife Naomi and their two sons, Mahlon and Chilion set out from their home in Bethlehem, in Judah, and headed off to Moab, where things were good, and there they settled. The two boys grew up and chose Moabite wives. Mahlon married Ruth and Chilion married Orpah.

Sadly, tragedy befell the family. First, Elimelech died, to be followed in time by both sons, leaving Naomi, Ruth and Orpah as childless widows.

Naomi, living in a foreign land with no husband, no grandchildren and with two Moabite daughters in law, became homesick for Bethlehem, and decided to leave. It's obvious both daughters in law loved her, for they were adamant they wanted to go with her. She strongly urged them to return to their families and find Moabite husbands. Finally, Orpah, weeping, agreed. She kissed Naomi and left.

43 Michael Coogan, ed., *The New Oxford Annotated* Bible: With the Apocryphal /Deuterocanonical Books: New Revised Standard Version. (Oxford New York, Oxford University Press, 2001), 391.

Ruth, on the other hand, resisted, despite even more urgings from Naomi.

At last Ruth spoke words that have remained among the most beautiful ever spoken, and they mirror an equally beautiful spirit:

Do not press me to leave you;
or to turn back from following you!
Where you go, I will go;
where you lodge, I will lodge;
your people shall be my people,
and your God my God.
Where you die, I will die –
there will I be buried.
May the Lord do thus and so to me,
and more as well,
if even death parts me from you.
Ruth 1:16,17

And so they set off together and arrived at last in Bethlehem, in Judah. Naomi was still wracked in sorrow. Even in her home town she could see no future – only blackness and despair. She said, (2:20): *'Call me no longer Naomi. Call me Mara'.* Mara means 'bitter', but she spoke too soon. God had plans for them both.

Most widows in those days lived in poverty. Naomi and Ruth had nothing even to put on the table, so Ruth spoke to her mother in law about gleaning. The Book of Leviticus 19:9,10 and 23:22 had a law to say that the poor could glean the fields, following behind the harvesters, to obtain grain for food.

As it turned out, Naomi's husband Elimelech had a relative in the district; a very well-heeled farmer, whose name was Boaz, so Ruth decided that would be a very good place to start. She must have been very attractive, for soon she came to the attention of Boaz. He was attracted, not only by her beauty but also by her gentle nature, her godliness and her virtue.

That first meeting in the fields was only the starting point, for over the following three chapters, Boaz fell in love with his kinsman's beautiful daughter in law.

Naomi, through her dead husband, still owned a small property in Bethlehem. The Law was that whoever acquired the property from her would also acquire *Ruth, the Moabite, the widow of the dead man, to maintain the dead man's name on his inheritance.* (Ruth 4:5).

Boaz dearly wanted Ruth to be his wife, and by a bit of honest subterfuge, he managed to buy the land belonging to Naomi, and so acquired Ruth as his wife.

Naomi too was well looked after, for in time Ruth bore Boaz a beautiful little son and heir.

Then the women said to Naomi, 'Blessed be the Lord, who has not left you this day without next-of-kin, and may his name be renowned in Israel! He shall be to you a restorer of life and a nourisher of your old age; for your daughter in law who loves you, who is more to you than seven sons, has borne him'. Then Naomi took the child and laid him in her bosom, and became his nurse. The women of the neighbourhood gave him a name, saying, 'a son has been born to Naomi'. They named him Obed; he became the father of Jesse, the father of David. (Ruth 4:17).

All's well that ends well! No more would Naomi want to be called 'Mara'. Her later life was filled with happiness. It's a gorgeous little love story and I urge you, if you haven't read it, to do so. You'll thoroughly enjoy it.

The importance of the Book of Ruth lies finally in the child she bore Boaz. Through Obed there is a direct line to the one who was to become Israel's great king, David. It is through this line that we trace Jesus' lineage. It's all in Matthew 1:1-17. Faithful, loving Ruth, the Moabite maiden, was part of the divine plan.

OPPONENTS WITHOUT AND WITHIN

We have now concluded our section on the magnificent prophetesses of the Hebrew Bible, who had such an impact on the history of Israel. Marg Mowczko who has an excellent website/blog[44] has found yet another book attacking the genuine prophetic role of Hebrew prophetesses. While not doubting the integrity of the authors of the book Marg quotes, she and many others (myself included) believe they err. This particular book is titled *Recovering Biblical Manhood and Womanhood* (RBMW). The prophetesses Deborah and Anna as well as Huldah also have their prophetic roles challenged in this book.

Referring to Huldah, its authors, John Piper and Wayne Grudem write in RBMW: 'Huldah evidently exercised her prophetic gift, not in a public preaching ministry but by means of private consultation'. The authors have based their conclusion largely on an argument of silence. The Bible does not say if Huldah prophesied regularly either publicly or privately. One cannot make an informed judgement based on a single incident; the only incident (2 Kings 22:14-20) in which Huldah's name or work as a prophetess is mentioned in the Bible. (The same story appears in 2 Chronicles 34:14-28). Marg rightly asks if that is a fair and reasonable way of assessing Huldah's ministry. I say no.

Mowczko writes, 'Huldah's ministry raises concerns for some people. She enters the narrative as one seemingly known and trusted by the king, sought with urgency, entreated by his highest officials, and consulted on the most authoritative basis possible ... Huldah was consulted by a group of men who were acting as envoys of the king who was acting on behalf of 'all Judah'. Like male prophets such as Micah, Huldah delivered warnings of divine judgement and punishment. Only a few male prophets are recorded as speaking to a crowd and, while the Bible does not record that Huldah spoke before a large

44 Marg Mowczko, 'Huldah's Public Prophetic Ministry', Blog, *Marg Mowczko: Exploring the biblical theology of Christian Egalitarianism*, 2018, accessed 1 April, 2018, https://margmowczko.com/huldah-prophetess/

group of people, we cannot rule out that she never did this. Huldah was a highly respected prophetess, as demonstrated by the fact that she was sought out by the king's men, and she would have prophesied on many other occasions that are not recorded in the Bible. Huldah, Deborah and Anna had speaking ministries. They heard from God and spoke for God and gave guidance to men. They are plainly identified as prophets in the scriptures. Moreover, there was a recognised and respected place for male and female prophets in Israel ... Huldah may even have been the official prophet of Josiah's court'.[45]

Some writers seem keen to convince their readers that prophetesses in the Hebrew Bible had a very restricted role in prophesying. Is there a hidden agenda here? Perhaps, if a convincing argument could be made that there is no historical evidence of prophetesses speaking publicly in the Hebrew Bible, it may also be argued that women should not be permitted to preach publicly in the New Testament. The argument in RBMW is too shaky to be taken seriously. An argument based on silence just does not have a leg to stand on.

In complete opposition to RBMW, the wonderful stories of Israel's prophetesses included in this book are not simply because they are interesting. They are in it because they are inspirational. They are reminders that God has used, and continues to use, both women and men in His service, at every level of activity and continues to do so.

People may delay, but not prevent, God's ultimate plan for the world. There is work to be done and people are called to do it. Already it should be obvious that God chooses whom He wills to achieve His purposes. Sadly, books such as RBMW serve only to deny women the dignity and honour that should be theirs, which God has given to them. Piper and Grudem acknowledge that Huldah, Deborah and Anna prophesied, but then attempt to convince readers that it was just a private thing – not a *real* prophetic ministry. It's another subtle way, if not meant, in which women are 'put down'; made to feel inferior, belittled. It grieves me and it is a matter of grief for us all.

45 Ibid.

Loren Cunningham writes that the temptation to keep women from obeying God's call on their lives is an attack on males in the Body of Christ. 'On the surface, this attack appears to be only against women, but when we look deeper, it is also against men. The enemy appeals to the pride of men by saying that women are not their equal, not worth as much.'[46] She also writes that when a bias against women is perpetuated by Christians, the message it sends is that God is unjust: 'A few years ago, I was in Zimbabwe preaching at a Christian conference. Afterward a young woman and her husband came up to speak with me. The woman had just completed seminary, graduating at the head of her class. Now she was not allowed to teach or preach. Her husband said, 'This is so unfair!' I had to agree. When Christian leaders act unjustly, it reflects on the character of God. Unbelievers watch and decide that if Christians are like that, their God must also be unjust. After all, if God gives gifts to a person, then prohibits her from using them, doesn't that make Him unjust? Justice, like judgment, must begin in the house of God.'[47] No wonder many women are hurt.

46 Loren Cunningham, David Joel Hamilton, and Janice Rogers, *Why Not Women: A fresh look at Scripture on Women in Missions, Ministry and Leadership, (Seattle, Wash: YWAM Pub, 2000).* Kindle Edition.

47 Ibid. 216

PART 2
THE NEW TESTAMENT

THE QUESTION OF WOMEN AND MINISTRY IN THE CHURCH.

In this section we'll take a look at a number of women, first in the Gospels, and later, in the Book of Acts and the Epistles, whose lives were influenced by Jesus. Twenty centuries on, the lives of women and men are still influenced by Jesus, but let's concentrate on the womenfolk in Jesus' day who were deeply influenced by him, while he in turn was deeply moved by their devotion and faith. None of those women held either leadership or preaching roles in Jesus' time. Had they attempted to take on something like that in the society of the day, the Good News would have finished there and then, such was the order of society in Palestine two thousand years ago (and are in places in the Middle East to this day). Women were subordinate and were not permitted even to speak to a man who wasn't a member of their family. Only ladies of ill-fame (prostitutes) did that, and they were considered to be outside the bounds of decent society. There were strict rules in place, and it was folly to contravene them. Amazingly, more than once, Jesus did. He developed strong friendships among women in the days of his flesh. There is nothing to suggest they had subordinate roles. Many were close, personal friends. The influence of those women and their friendship with Jesus was to have a flow-on effect to the women of the early church. We can say that right from the beginning of Jesus' ministry on earth, through to the early church and into the ages since, as society and rules have changed, women have been integral in the life of the Gospel. They have loved the Gospel, preached the Gospel, taught the Gospel, written of the Gospel and in many cases, have died for the Gospel.

ANNA – THE PROPHETESS WHO SAW JESUS

There was also a prophet, Anna, the daughter of Phanuel, of the tribe of Asher. She was of a great age, having lived with her husband seven years after her marriage, then a widow to the age of eighty-four. She never left the temple but worshipped there with fasting and prayer night and day. At that moment she came and began to praise God and to speak about the child to all who were looking for the redemption of Israel. (Luke 2:36-38).

Anna is not in the Old Testament, and only just in the New, and mentioned only once, here in Luke's Gospel. She was eighty-four years of age, which suggests to me that she stands, in a strange sort of a way, between the Testaments. If she doesn't get a mention here, she won't get a mention anywhere – and the fact is, she prophesied.

Old Simeon, awaiting the consolation of Israel, saw the baby Jesus in the arms of His mother when the parents came to the temple to present their baby to the Lord and to offer a sacrifice. Simeon had been told by the Holy Spirit that he would not die until he had seen the Messiah. (Luke 2:26). Overjoyed, he prophesied concerning Him (Luke 2:25-32).

Anna the prophetess, holy and devout, also saw the baby Jesus in the temple that day, and also prophesied. It is plain that she too awaited the day when the Messiah would come, and all Israel's suffering and pain, generation after generation of it, would be redeemed. For many years since her widowhood she had kept faith in the temple, awaiting that very day, and spoke about the Child *to all who were looking for the redemption of Jerusalem.* 2:38).

Such beautiful faith is humbling, and this lesson in humility and devotion to God is brought to us quietly by that little lady, a prophetess, whose faith remained constant. I feel sure she would have approved the words Simeon spoke, of what has come to be known as the *Nunc Dimittis* which is Latin: 'Nunc' means *Now*: 'Dimittis' means *Depart*. Simeon asked permission from God to die – he'd seen everything:

Lord, now let Your servant depart in peace;
For my eyes have seen Your salvation,
Which you have prepared in the presence of all peoples;
A light to reveal You to the Nations
And for glory to Your people Israel (Luke 2:29-32).

How wonderful if our faith could remain as constant as Anna's and Simeon's, despite all that life may throw at us! Moved by the faith of these ancients, let's keep trusting God, knowing that He always keeps His Word, and wait patiently for the culmination of the ages: a new heaven and a new earth ... *But about that day and hour, no one knows* (Matthew 24:36).

..........................

PS: I noted that the NRSV has translated Anna as a 'prophet'. (*There was also a prophet, Anna ...* (Luke 2:36). When I went back to the Greek New Testament, I saw that the Greek word used is προφῆτις ('prophetess'), not προφήτης ('prophet').

It may seem a small matter, making the name generic, but to translate a feminine word into what is masculine, even if generic, is part of the overall problem.

MARY – JESUS' MOTHER

There are about fourteen women mentioned in the Gospels, but we'll concentrate on those more specifically mentioned in relation to Jesus.

First, of course, there was Mary, Jesus' mother. Joseph seems to have left the scene quite early. Possibly he died at an early age. Both parents are mentioned when Jesus was presented at the temple in Jerusalem. Twelve years later, he managed to stay behind in Jerusalem when Joseph and Mary took him there for the Passover. On the way back they couldn't find him, so had to return. They found him in the temple, swapping theology with the Jewish academics. When his mother told him they'd been so worried for him, he replied, *'Didn't you know that I had to be in my Father's house?' But they did not understand his answer.* (Luke 2:49,50).

Years of silence follow, until his ministry begins with the arrival of John the Baptist.

We turn to John 2:1-11, where he and his family are at a wedding party in Cana, near Nazareth, in Galilee. Jesus' answers to his mother are sometimes difficult to understand. His reply to his mother when he was aged twelve is a good example. I think that reply may have been typical. Jesus was not your average twelve year-old.

Years later, at a wedding feast, the guests gave the wine a hearty nudge and it didn't last long. Let's picture the scene; something we can imagine happening here in modern day Australia: The guests are wandering about, holding their empty schooner glasses and asking plaintively, 'What are we gunna do?' There was no Holden ute to jump into and drive down the town to Abe's Wine Cellar, in those days. The hosts are embarrassed.

Mary probably said, 'I'll have a word with Jesus. He may be able to organise something'. She had complete faith in her son.

She found Jesus and said, 'Son, they've run out of wine'.

Jesus gives vent: 'Mum, what do you mean, coming here, telling me they've drunk all the booze, while my whole being is caught up in how God is using me to bring the Good News to all? It's going to cost me my life!'

She turned to the servants. 'Just do whatever he tells you' and left them to it.

John's Gospel words it differently: *'Woman, what concern is that to you and me? My hour has not yet come'* (John 2:4).

'Woman ...' It sounds discourteous to our ears, but in Jesus' day it was an expression of respect. Jesus loved his mother. I think that in this incident, Jesus' mind is totally concentrated on all that lay ahead: the establishment of the Kingdom of God on earth. Ahead lay problems that must have appeared insurmountable. 'My hour' signifies his coming death on the cross ... Now his mother comes to him to let him know the wedding party has run out of wine. We can also understand that his coming agonizing death weighed heavily on him. He was human after all.

Here at the wedding feast in Cana of Galilee, Jesus used the lack of wine as a sign of the coming of the Kingdom. He turned the water in six large water jars into high quality wine. The water jars were for purification; for washing hands and for cleaning dusty feet. The amazing thing is, the jars all held about 90 litres each, so there were about 540 litres of top quality wine in those jars – in a society where drunkenness was despised. Why did Jesus change so much water into wine? I hear you ask. John calls Jesus' miracles 'signs' to indicate that the 'miracles' are not just party tricks. There is meaning behind them. The quantity is symbolic of God's lavish generosity, and the new wine represents the coming of the New Covenant. The steward tells the bridegroom, *You have kept the good wine until now.* (John 2:10).

After this he went down to Capernaum with his mother, his brothers and his disciples; and they remained for a few days. (2:12).

That one sentence tells us a lot. The Romans had turned Capernaum into a resort city. It had hot springs; it was on the shores of the sea of Galilee, known to the Romans as the sea of Tiberias, after the emperor of that name, and it had a great temperature. It had lovely holiday villas and hotels and in fact we can picture it as a sort of an ancient 'Sunshine Coast'. While the text doesn't say so, we have to imagine that Jesus, his brothers and the disciples are down there for a holiday for a few days, watched over by Jesus' loving, quiet mother. Can you imagine Jesus really enjoying himself with his friends, lying back in a hot spring, going for a swim in the sea, sitting at a café table, laughing and joking with his brothers and friends? We really have to clothe many of the stark stories we find in the Bible with life, for they were all people, as are we. In all these scenes I see Jesus' mother and feel something of the sense of sadness she must have felt. She didn't understand her son, but she loved him dearly. There had been his mysterious conception, and the stable where he was born; shepherds who told of angels, and later, those men from the East with their gifts. What would happen to her son? Right now we can see her enjoying a few days off with her boys and their friends. She deserved it.

We find Jesus' mother again just after her son had chosen his twelve disciples. (Mark 3:13-35). Huge crowds gave him no rest as they pressed upon him to be healed. When his family heard about it, they went out to restrain him, for people were saying, 'He's out of his mind'. (v.21). Can you imagine how terrible that would have been for Mary? She must have been heart-broken; despairing for her son. Word went round that he was possessed by Beelzebul, the prince of demons. Jesus' family must have been frantic with worry; especially his mother, for no one, apart from God, loves like a mother. There is no mention of the support of a husband, for Joseph is apparently dead. Jesus obviously didn't live in the family home for in verse 31 again they were outside his house: *Then his mother and his brothers came; and standing outside, they sent to him and called him.* I suggest they couldn't get near him because of the huge crowds inside and outside the house. I'm sure Mary must have been weeping bitterly, hanging

on to her other sons. Jesus said to those inside the house, *Whoever does the will of God is my brother and sister and mother.* (verse 34). It's easy to criticise Jesus here, but we have to remember that all that he has to accomplish has to be done in three short years. Many of the listeners had no hope of being loved by anyone: the outcasts, the abandoned, the dregs of society. Now they have mothers and brothers and sisters through Jesus – the new family of faith in the coming Kingdom, but time is running out. All this ties in with Jesus' outburst at the wedding in Cana of Galilee. The kingdom is starting to grow. The lame walk, the deaf hear the blind see. Jesus is exhausted, looking and sounding wild. He's under the control of the Holy Spirit – not even having time to stop to eat; probably sleepdeprived. He must have looked a somewhat wild figure.

To get a better picture in our minds, let's take time off to see Jesus, back at the beginning of Mark, out there in the wilderness, being tempted by Satan. (1:12,13). Mark's Gospel records: *Immediately the Spirit DROVE him out ...* ἐκβάλλει. (ekballei-drove) That's powerful stuff.

Now - back to our story. Here is Jesus, looking a bit on the wild side, is *driven* by the Holy Spirit, while his family, whom he loves, will have to go on the backburner for a little while. And yet our heart goes out to Mary, the mother of a son regarded by the authorities as under the control of demonic powers. She grieves for him, unable to contact him or comfort him. Possibly she thinks at this point of time that her son has indeed 'lost the plot'. We share Mary's life of grief, not yet over, for the cross looms ahead, waiting to crush her heart again.

The great New Testament scholar Dr Leslie Weatherhead wrote, 'We pass through these early pictures, feeling that a shadow falls between the mother and her son, the shadow of misunderstanding ... The spiritual world for him is becoming all-important and the part He Himself is going to play is gradually becoming revealed to Him'.[48]

48 Leslie D. Weatherhead, *Personalities of the Passion,* (London: Hodder and Stoughton Limited, 1955,) 91.

Now we move on in time to the stark tragedy of Golgotha and the cross, where Jesus hangs, dying (John 19:16-28). John records. *Meanwhile, standing near the cross of Jesus were his mother, and his mother's sister, Mary the wife of Clopas, and Mary Magdalene. When Jesus saw his mother and the disciple whom he loved standing beside her, he said to his mother, 'Woman, here is your son'. Then he said to the disciple, 'Here is your mother'. And from that hour the disciple took her into his own home.* The disciple Jesus loved is almost universally believed to be John, to whom he entrusted his mother as he died.

On top of a high hill some distance from the ancient ruins of the city of Ephesus in Turkey stands a small and ancient house. It's a rather tiring walk even after one gets out of the bus to walk up to the house. It is here that John is said eventually to have taken Mary, the mother of Jesus, to live. John had an adventure-filled life. He'd done time on the island prison hell-hole of Patmos for witnessing to Jesus, where it is believed he wrote the Book of Revelation, about 98 CE. He wrote a total of five books in the New Testament and died somewhere after the turn of the first century, a very old man. Mary died years before him – possibly as early as 48 CE, but she would have been about sixty-five. By then her work as Jesus' mother was done, but still she is loved and revered in much of Christendom to this day. She stands as a model of peerless faith, love and devotion.

I visited John's house near Ephesus a few years ago. The house has been made into a shrine by the Catholic Church. Any evidence that it was once a house in the ordinary sense has long been removed, to be replaced by relics and other religious objects which have turned it into a shrine. As I looked about, I found it hard to imagine Mary living there, doing a bit of cooking, banging the pots and pans about, setting the table, singing as she worked ... and there in the back yard is John, very old now, feeding the chooks and gathering some eggs in a dish. As I said, I tried, but couldn't really imagine it. Too many years have passed, and a shrine is not a home.

MARTHA AND MARY

So much happened in the life of Jesus that has never been recorded, simply because there isn't room for all the stories. We could do well to take notice of the closing two verses of John's Gospel: *This is the disciple who is testifying to these thing and has written them, and we know that his testimony is true. But there are also many other things that Jesus did; if every one of them was written down, I suppose that the world itself could not contain the books that would be written* (21:24,25). An example is in this story, for we don't know how Jesus' initial contact with Martha, Mary and Lazarus blossomed in time into deep affection.

In Luke's Gospel we have an account of a time when Jesus visited this little family he'd come to know and love. (10:38). Martha appears to be the principal person in the home. She was the one who attended to the visitors, managed the house and did most of the work. Mary, on the other hand appears to be a bit of a dreamer. On this occasion, as Martha bustled about, preparing the meal, setting the table, Mary *sat at the Lord's feet and listened to what he was saying.* (10:39). This irritated Martha, doing all the work, so she came to Jesus and said, '*Lord, do you not care that my sister has left me to do all the work by myself? Tell her then to help me*'. It seems that Lazarus wisely kept out of that one! He doesn't get mentioned.

Jesus answered, '*Martha, Martha, you are worried and distracted by many things; there is need of only one thing. Mary has chosen the better part, which will not be taken away from her*'. (10:41,42).

So how are we to read that? On the surface, it seems so unfair: There's Martha, toiling away in the kitchen, irritably banging the pots and pans about, while Mary is reclining at Jesus' feet and listening, doing nothing to help. Let's remember however that Jesus' ministry on earth must fit into one brief window in time. Is the time to teach being swallowed up in the dishwasher? Jesus tells Martha that Mary, the quiet and pensive one, has chosen 'the *better* way' – which seems

to indicate that there are two ways; both good, but one better. In time, Jesus is saying, Martha's choice would die with her, while Mary's choice was spiritual and eternal. Both were ways of honouring the Lord. In the Church of the future, both would be necessary. God's people engage in all the work of running the church: plannings, meetings, rallies, organising, raising funds for the life of the church and its pastoral activities and so much more. Life in the Church is not a bed of roses. It never stops. There's always work to be done - and usually there is more work than helpers. The saying is true: 'The world is full of willing people: a few willing to work and the rest willing to let them'. On the other hand there must be preachers and teachers and scholars and theologians and historians, and all manner of people associated with maintaining the ongoing spiritual/prayer life of the church. In the life of the Church community, both are needed, both vital. *Women are called to both*. It's reasonable to suggest that this story, with Jesus' explanation, supports that statement.

Now let's move on to another encounter with the family. John's is the only Gospel where the following account is recorded. We learn that Lazarus became very sick. The sisters whipped off a quick email to Jesus. *'Lord, he whom you love is ill'*. (11:1, 3).

By the time Jesus received the message of Lazarus's illness, and he and the disciples got to Bethany, it was to learn that Lazarus had died four days previously. Jesus walked into a floodtide of grief as Martha and Mary mourn their dead brother. Martha went out to meet Jesus and said *'Lord, if you had been here, my brother would not have died'*. It seems almost a rebuke. Jesus replied that her brother would rise, but Martha misunderstood, thinking Jesus was talking about the last day – the end of time. Jesus' reply to Martha was profound; a statement she was the first to hear, spoken today at just about every Christian funeral service: *'I am the resurrection and the life. Those who believe in me, even though they die, will live, and everyone who lives and believes in me will never die.* Then he said, *'Do you believe this?'* (11:25,26).

Martha replied with a confident confession of faith: *'Yes Lord, I do believe that you are the Messiah ...'* (11:27).

She and Mary took Jesus to the tomb where their brother lay. They were weeping, and Jesus himself wept. Doubtless he wept because he was moved by their grief, and his love of the family. Gail R. O'Day writes, 'Jesus weeps also because of the destructive power of death that is still at work in the world. Once again one sees the intersection of the intimate and the cosmic: the pain of the family reminds Jesus of the pain of the world'.[49]

Jesus performs another of his signs by raising Lazarus from the dead. With the coming of the Messiah the lame walk, the blind see, the deaf hear and the dead are raised.

Six days before the Passover, Jesus came to Bethany, the home of Lazarus, whom he had raised from the dead. There they gave a dinner for him (no doubt this was a lovely little celebratory dinner: Lazarus is alive! There he is, at the head of the table, party hat at a jaunty angle, chatting away, smiling happily, giving the Gorgonzola and bikkies a good nudge) ... *Mary took a pound of costly perfume made of pure nard, anointed Jesus' feet and wiped them with her hair. The house was filled with the fragrance of the perfume* (John 12:1-3). It was an act of extravagance, compelled by devotion. O'Day makes three points here: First, Mary's anointing anticipates Jesus' death and burial. He will be anointed again secretly when in the tomb, by men who are too afraid to make public their faith (19:38,39) – but Mary publicly anoints Jesus before all the diners. Second, the anointing of Jesus' feet is a model of service and discipleship and third, it anticipates the love commandment that Jesus will give his disciples: *Love one another. Just as I have loved you, you also should love one another.* (13:34,35). 'Mary is the first person in the Gospel to live out Jesus' love commandment'.[50]

49 Gail R. O'Day, 'John', *The Women's Bible Commentary*, Carol A Newsom and Sharon H. Ringe, Eds. (London: SPCK 1992) pp. 298-299

50 Ibid. 301

The story of Martha, Mary and Lazarus seems to concentrate as much on the faith, hope and love of the sisters as on the miracle itself. Their faith hope and love is a forerunner of the virtues that women will exercise down the ages, to the present. The story also demonstrates peerless courage. Women from private soldiers to senior officers serve as combatants in our Defence Force. They serve in war zones – in the field. They fly fighter aircraft and also serve as chaplains in all branches of the Defence Force. Women are warranted officers from junior constables to senior police officers in our police force, and women also serve as police chaplains. They deserve to have leadership positions in the Church. There are far more of them in the church than men. They are involved in just about everything else.

Adonai gives the command; The women with the good news are a mighty army.[51]

51 Psalm 68:11. (Complete Jewish Bible)

THE WOMAN AT JACOB'S WELL

(John 4:7-42)

Jesus and the disciples had been taking the Good News to Judea in the south when they became aware that the authorities were becoming increasingly interested in their activities, so it was decided to return to Galilee by the shortest route, which was through Samaria, which lay in the middle between Judea and Galilee. The Jews and the Samaritans despised each other. It was one of those long-term affairs, generated after the northern kingdom of Israel, Samaria, was defeated by the Assyrians after a three-year siege, and the locals started to intermarry with the foreigners. They were no longer considered Jews, but a mixed breed of those who had betrayed their inheritance.

As they passed through Samaria, nearly half way to Galilee, they arrived at the village of Sychar. A short distance from the village was Jacob's well, so Jesus, footsore and weary, made his way there to rest. Possibly, looking at the well, he reflected on the great Patriarch, Jacob, whose story is in the Book of Genesis and who, tradition said, built the well nearly two millennia before. The disciples weren't with him. They had stayed in the village to purchase food (4:8).

The following is truncated, but please read the biblical account for yourself.

Shortly after Jesus arrived, a Samaritan woman came to draw water from the well, and Jesus asked her for a drink.

She replied, 'Why do you, a Jew, ask me, a Samaritan woman, for a drink?'

Jesus gave one of his enigmatic replies (v.10): *If you knew the gift of God, and who it is that is saying to you, 'give me a drink', you would have asked him, and he would have given you living water.*

For a while the woman's replies seem to have a bantering quality as she seeks to get the measure of the Galilean stranger.

'Get real! You don't have a bucket and the well is deep. Where do you get this living water? Are you greater than our ancestor Jacob, who gave us the well?'

'Everyone who drinks this water will be thirsty again. Those who drink the water I give will become a spring of water, gushing up to eternal life'.

'Wow! Give me this water, so that I may never be thirsty, or keep coming back here to draw water!' She was still in a bantering mode.

Jesus decided to up the ante (v.16): 'Go and fetch your husband and come back!'

The lady looks a little coy: 'Well, actually, I don't have a husband'.

Jesus gives a snort. 'You got that right! You've had five of them, and you're living with some bloke now!'

Suddenly our lady was on the back foot. She tried to change the subject but the talk got progressively deeper.

Finally she said to Jesus (v.25): *I know the Messiah is coming, and when he does, he will proclaim all things to u'*.

(v.26): *Jesus said to her, I am he, the one speaking to you.*

The woman rushed off back to town, where she called out excitedly to any who would listen (v.29): *Come and see a man who told me everything I have ever done! He cannot be the Messiah, can he? They left the city and were on their way to him.*

A crowd went out to see Jesus because of the woman's testimony and they were impressed with what they heard. They asked him to stay on awhile, so he and the disciples stayed another two days. (v.41): *And many more believed because of his word.*

This is an amazing story. From a seeming chance encounter, crowds of Samaritans came to believe in Jesus as the Messiah. He drew them from the rivalry and hatred that had inflicted them for about five hun-

dred years and brought them into the family that was to become the Christian Church.

And what about the woman who walked to the well one day, carrying her jar, never imagining what was in store for her? Do we know what happened to her?

Surprisingly, there is a very strong tradition concerning her that exists to this day in the Eastern Orthodox Churches. The tradition tells us that her name was Photina. She with her family became devout Christians. Photina became St Photina after she was martyred in Rome during the Neronian persecutions, along with Perpetua, another woman martyr.

There are many traditions in the Christian Church and when we say 'traditions' it means there is rarely written evidence to support them. Tradition tells us that both Peter and Paul as leaders of the early Christian Church also perished in the first wave of Nero's persecutions in 67 CE. It's highly likely but we can't confirm it. We can't confirm that Peter died on an upside-down cross because he said he was not worthy to be crucified in the same manner as Jesus; neither is there written evidence to say that Andrew was martyred in Greece on the type of X cross that bears his name. Tradition tells us that some of his bones ended up in Scotland and were buried in the place that eventually became the great city of St Andrews.

One thing we can say for certain: the woman who met Jesus at Jacob's well in Samaria was yet another woman who proclaimed to all who listened that Jesus is Lord.

MARY MAGDALENE

A certain aura of mystery surrounds Mary, who came from the fishing village of Magdala, on the north-west shore of the Sea of Galilee; hence 'Mary Magdalene'. She has been confused with the nameless woman of the streets who took a jar of precious ointment and anointed the Lord's feet (Luke 7:36-50); with another woman who anointed Jesus' head in the house of Simon the leper, (Matthew 26:7); and with Mary, Martha's sister, who also anointed the Lord's feet. (John 12:3). The New Bible Dictionary tells us that it is 'necessary to resist any identification with Mary Magdalene and the 'sinful woman' of Luke chapter 7'.[52] There is no mention of Mary Magdalene's ever anointing Jesus.

It is surprising how many times Mary Magdalene's name drifts through the Gospels. She and several other women are recorded as accompanying Jesus and the disciples as they travelled the countryside, proclaiming the Good News. The women provided for them out of their own resources. Luke names some of the women: *Mary Magdalene, Joanna, the wife of Herod's steward Chuza, Susanna, and many others*. (Luke 8:2). One gains the impression that the women who are named were known to the early church.

The mystery continues - it is such a pity that once again we have only the bare bones of a remarkable story. As with the Bethany family: Martha, Mary and Lazarus, we are left wondering how Jesus' great friendship with Mary Magdalene developed. All four Gospels mention her, but apart from Luke 8:2, all the references are centred around the crucifixion and the tomb. Mary's love of Jesus becomes clearer as we move to the crucifixion and beyond.

John 19:55: *Meanwhile, standing near the cross of Jesus were his mother, and his mother's sister, Mary, the wife of Clopas, and Mary Magdalene.*

52 J.D. Douglas, ed., 'Mary' *The New Bible Dictionary*, (London: Intervarsity Press, 1975), 792.

After Jesus was pronounced dead, two of his close friends, Joseph of Arimathea and Nicodemus, took his body, wrapped it in linen with myrrh and aloes, and laid it in a tomb in a garden (John 19:38-42).

John 20:1: *Early on the first day of the week, while it was still dark, Mary Magdalene came to the tomb and saw that the stone had been removed from the tomb.*

Professor William Barclay, the Scottish New Testament scholar writes, 'The part that love plays in this story is extraordinary. It was Mary, who loved Jesus so much, who was first at the tomb'[53]

John 20:2: *So she ran and went to Simon Peter and the other disciple, the one whom Jesus loved, and said to them, 'They have taken the Lord out of the tomb, and we do not know where they have laid him'.*

John 20:3-9: Peter and the other disciple ran to the tomb and saw it was as Mary had said. Simon Peter *saw the linen wrappings lying there, and the cloth that had been on Jesus' head, not lying with the linen wrappings but rolled up in a place by itself.* There can be little doubt about it – this graphic account is from one who was there, whose mind will never forget what he saw in the tomb on that first Easter morning. Barclay notes that the linen wrapping and the headpiece were still lying in their folds – for that is what the Greek means, Barclay adds - not crumpled and dishevelled but still retaining the shape they'd had when Jesus was wrapped in them, as if his body had evaporated.[54]

John 20:10: *Then the disciples returned to their homes.*

John 20:11-18: Mary did not return to her home, but stood weeping by the tomb. She bent to look inside and saw two angels; one at the head and one at the foot, where Jesus had lain. They asked her why she was weeping and she replied, (v.13) *'They have taken away my Lord and I don't know where they have laid him'.*

53 William Barclay, *The Gospel of John, Vol. II* (Philadelphia: The Westminster Press, 1975), 267.
54 Ibid.

At that point she turned to see a figure standing by her but she, consumed with grief, didn't recognise him.

He spoke to her (v.15): *'Woman, why are you weeping? Whom are you seeking?*

She thought he was the gardener: *'Sir, if you have carried him away, tell me where you have laid him, and I will take him away'.* John's words, plain and unadorned, still manage to capture something of the grief and despair that overwhelmed Mary. All who have loved and lost will recognise the depth of anguish that only the death of a dearly loved one can bring.

(v.16) Jesus said to her, *'Mary!'* Jesus loved Mary. That is plain. Try to capture something of the emotion behind that single word. I can see tears in his eyes; his face full of tender emotion: ἀγάπη – (agapé - spiritual love); very, very deep, very spiritual.

(v.16, continuing). *She turned and said to him in Hebrew, 'Rabbouni!' (which means Teacher).*

Mary's response: 'She ... *said* to him' is a lesson in understatement. I think it would be more of a cry of amazement and joy, but the writers of the scriptures don't use that sort of language. 'Rabbouni' means more than 'Teacher'. It is found only three times in the Gospels: 'An Aramaic form of a title almost entirely applied to the president of the Sanhedrin if such was a descendant of Hillel. It signifies 'my great master'.[55] Mary's use of that word indicates that the love shared by Jesus and Mary was spiritual, not romantic. That it was love is unmistakable in what follows.

John 20:17a: *Jesus said to her, Do not hold on to me ...* That reads as if Mary was about to hold Jesus but he prevented her; however the Greek tells us something else. The words used here are in the present

55 W.E. *Vine's Complete Expository Dictionary.* p. 504.

imperative and can mean 'stop touching me' or 'stop holding me' or 'stop clinging to me'. The trouble with translations occurs when there is more than one option, but according to the Greek, Mary was already holding onto Jesus, clinging to him or touching him. In light of the emotion expressed here, I suggest either 'holding on to' or 'clinging to' which are expressions of Mary Magdalene's deepest love. Jesus goes on to say ... *for I have not yet ascended to the Father*. It seems as if some mysterious process was taking place within his body, transitioning it from its earth-bound frame. Contact will be after he has ascended to the Father. Exactly the same failure to recognise Jesus initially occurred on the same first Easter day when two disciples (Cleopas and almost certainly his wife) were walking to the village of Emmaus, when they were joined by a stranger, whom they didn't recognise – until, sitting at table with them in their house, he broke bread – and at once their eyes were opened. They rushed back to the upper room in Jerusalem, where all the other disciples were hiding: 'We have seen the Lord! He was known to us in the breaking of bread!' A week later, in the upper room, he would invite Thomas, who did not believe he had risen from the dead, to touch him - to put his finger in the nail prints in his hands and put his hand in his side, where the soldier's spear had penetrated (John 20:27). The transition was complete.

From that point, Mary Magdalene disappears from the pages of scripture, but we can be sure she continued to spread the Good News.

As we close the chapter on this wonderful, remarkable and godly lady, I confess to being left with a strange, empty sort of a feeling; like reading a good book or watching a good movie where the ending was not as one would have wished. One part of me asks if Jesus, Son of God, was exempt from all feelings of romantic affection. Let's remember that the Jesus of history was human, as we are. We may ask if that emotion was simply stifled because of who he was and what was required of him. On six occasions in John's Gospel we read of 'the disciple whom Jesus loved', but 'love' as a word is never

associated with Mary and Jesus. At the same time, it is unmistakably implied. If there was love it was the αγάπη (agapé – pure, spiritual) love. Then again, it would have been highly inappropriate, I suppose even to suggest it, when John wrote his gospel.

We can attribute a few things to Mary. She was one of the few who knew and loved Jesus, to stand by his cross. She was the first to go to Jesus' tomb and find it empty. She was the first to see the risen Lord. It was she whom Jesus commissioned with the triumphant message to take to the disciples: *I am ascending to my Father and your Father; to my God and your God* (John 20:17b).

We can leave her with a message she would have loved: The word from the New Testament is that the Lord commissioned women to proclaim the Good News. What right has anyone, two millennia on, to take that commission away from them?

............................

Gail R. O'Day after examining the material found in John's Gospel 2:1-11; 4:4-42; 7:53-8:11; 11:1-44; 12:1-8; 19:25-27; 20:1-8, concludes: 'The seven passages discussed above show the pivotal place women occupy in the unfolding of the story of Jesus in the Gospel of John. In addition to these passages, there are general theological themes in the Gospel that need to be highlighted. While these themes do not deal with or address women specifically, consideration of them from the angle of women's concerns offers a fresh perspective on John that might otherwise be overlooked'.[56]

The error many make is an unconscious wish to lock the Holy Spirit within the literal confines of words. It's safer that way; yet the words of the Gospel point to the Spirit, Who challenges us to look beyond the words to what is being conveyed to us. O'Day writes that it is easy to be deceived by the simplicity of words, such as Jesus' new commandment, that we are to love one another as He loves us. (John 13:34,35). 'The Johannine language of the fullness and abundance

56 Gail R. O'Day, *The Women's Bible Commentary*, 302

of love is very important for women, because a one-sided emphasis on emptying and self-denial has led many women (and some men) to subscribe to an ethos of perpetual self-sacrifice and the meaninglessness of self. The Gospel of John provides a much-needed balance'.[57] In other words, not to love one another as Jesus loves us; not to love our neighbour as we should love ourselves, (Mark 12:29-31), spiritually impoverishes us. We are called to love ourselves as loved by God. To do otherwise may lead us to believe that we are worthless, or worth less. God has created each of us equally, in His own image (Genesis 1:27): 'male and female He created them', with a beautiful soul. He didn't create one to be more worthy than the other. Walk worthy of your high calling as His child.

57 Ibid. 302-3

THE EPISTLES

Now we push out into deeper waters ... If you were to say to me, 'I believe in the Bible exactly as it is written – not a word should be altered!' I would have to reply, 'And what version would that be?' There's the old joke about the King James (Authorised) Version: 'If the King James Bible was good enough for St Paul, it's good enough for me!' Advances in textual criticism and computer technology, biblical criticism, research developments and skills, have played their part in advancing our knowledge since the Authorised Version greeted the world in 1611. For instance, if you turn to the Letter to the Hebrews in the AV, you will see that the heading is 'The Epistle of Paul The Apostle to the Hebrews'. Today, no Bible apart from the AV includes Pauline authorship. No one knows who wrote Hebrews, written (it is generally thought) between 60 and 100 CE.

That's the trouble: no versions of the Bible are exactly the same. That's because a Greek word may have more than one meaning. How can we know what the writer was thinking at the time? There is a number of ancient Greek manuscripts, or codices. What word to choose from which manuscript? It can have translators scratching their heads. Some may give a different slant to a Greek word, so that a particular translation of the Bible will be a little different in places from other versions. The English language has the same problem. Words that have exactly the same spelling may have more than one meaning. Here's an example:

A small boy runs up to his maternal grandmother, who lives with the family.

'Grandma,' the boy says, 'make a sound like a frog'.

The elderly lady looks at him, puzzled. 'And why do you want me to do that, Tommy?'

'Well', Tommy replies, 'I just heard dad say to mum, 'I can hardly wait until your mother croaks!'

The problem of translation has had a major effect for women in the Epistles. Errors in translation alter meanings. Here is one that I picked up recently. I wasn't even looking for it. I was looking at something different in the text: 1 Corinthians 3:5, and I'll demonstrate how three different version translate the text.

The NIV: *What, after all, is Apollos? And what is Paul? Only servants, through whom you came to believe – as the Lord has assigned to each his task* (26 words).

The Good News: *After all, who is Apollos? And who is Paul? We are simply God's servants, by whom you were led to believe. Each one of us does the work which the Lord gave him to do.* (35 words).

The NRSV: *What then is Apollos? What is Paul? Servants, through whom you came to believe, as the Lord assigned to each.* (20 words).

So what's the problem? Only a few fill-in words and changed words, surely? Actually, no. Only the NRSV is correct. Only it follows closely the Greek text. Both the others assign a masculine gender to the Greek text, ('his' and 'him') where there is none. Those mistranslations are not insignificant. They reinforce all the other gender inaccuracies and deliberate lies, to the detriment of women.

There is much worth noting when it comes to the question of textual purity and what version of the NT we favour. Now turn to 1 Corinthians 15:3-6. I am quoting from the NRSV, one of the most authoritative versions of the Bible: *For I handed on to you as of first importance what I in turn had received: that Christ died for our sins in accordance with the scriptures, and that he was buried, and that he was raised on the third day in accordance with the scriptures, and that he appeared to Cephas, then to the Twelve. Then he appeared to more than five hundred brothers and sisters at one time ...* The text says that the Lord appeared next to James, then the rest of the apostles and finally to Paul himself. What puzzles me is the fact that there is NOT A SINGLE MENTION OF THE WOMEN, despite the fact that all four Gospels tell us that the women were *first* at the

empty tomb, and it was they who called the disciples. Only on two occasions of the discovery of the empty tomb does Peter rate a mention at all. Luke tells us that when the women told the disciples, they didn't believe them, and thought it was an idle tale, but Peter got up and ran to the tomb (24:12). If anyone should have been mentioned, it was Mary Magdalene, for she is mentioned by name as being at the tomb early in the morning in all the Gospels. It seems that attempts to minimize the significance or importance of women throughout the New Testament are unrelenting.

It should be noted that there are two extremes. On the one hand there are ongoing attempts to reduce the importance of women in the scriptures and on the other hand there have been some versions of the Bible that have sought to remove any suggestion that men and women had any gender at all! Of course it has resulted in some amazing, and grammatically horrifying, linguistic contortions; quite apart from being completely wrong as far as God's Word is concerned. He created us, male and female and we should be happy to acknowledge what we are.

The older translations of the New Testament epistles, such as the RSV, mention only 'brothers' or 'brethren' when addressing a group of people where one would assume there were both men and women, such as a congregation. Those versions are following literally what the Greek says. For instance, in Romans 12:1, Paul writes, *I appeal to you therefore, brothers* ... (adelfoi, adelphoi; literally, brothers. See the older version of the NIV) while the NRSV has correctly translated 'adelphoi' as *'brothers and sisters'*. Most would assume that the NRSV is simply bowing to modern convention, being inclusive in its language, but not so. 'Adelphoi' can be included in texts where it would be assumed that both men and women were present. It means that those who claim that Paul, for instance, writes only of 'brothers' – men – are wrong. The use of 'brothers and sisters' is correct: 'The modern reader may be misled into thinking only males are being addressed in certain contexts, when in reality they are not. So, modern English versions, in an effort to be accurate, especially when a congregation

is addressed, translate *adelphoi* with the phrase 'brothers and sisters.' (cf. New Living Translation; New Revised Standard Version; NET; Today's New International Version; and the NIV 2011). It is accurate to translate 'adelphoi' with the phrase 'brothers and sisters' when a congregation is addressed, when the universal group of Jesus' followers is under discussion and when it can be shown from the context that a religious group is under consideration.'[58]

Daly's statement is confirmed by a footnote in the English Standard Version of the Bible (1 Thessalonians 1:4): 'In New Testament usage, depending on the context, the plural Greek word *adelphoi* (translated 'brothers') may refer either to *brothers* or to *brothers and sisters.*[59] In other words, *adelphoi* can be generic in mixed company.

The sad truth is, over all the years that most Bibles have translated 'adelphoi' only as 'brothers', the real losers have been women, who once again have had their right to be included, denied them.

58 R. Daly, 'Adelphoi', *Biblical Language Research: Grammatical, Lexical and Historical Studies of the Hebrew text, Septuagint and Greek texts of scripture; especially as they relate to correctly explaining and translating the sacred writing,*April 12, 2011, accessed April 4, 2018, http://biblicallanguagesresearch.blogspot.com.au/2011/04/adelphoi.html

59 Crossway Bibles. *The Holy Bible: English Standard Version Containing the Old and New Testaments* (Wheaton, Illinois : Crossway, [2016] ©2001)

PAUL'S LETTER TO THE ROMANS

(chapter 16:1-16)

There can be little doubt about it: Paul is one of the most maligned people in the New Testament, because of his perceived hard-line attitude towards women. If your thoughts are along those lines, perhaps what follows may challenge that perception, and, one hopes, even help you to see him in a new light.

It is believed that Paul wrote the Letter to the Romans in the period 57-59 CE, probably while in Corinth. He had long expressed a desire to go to Rome, (as indicated in Romans 15:23) and hoped to go on from Rome to Spain. (15:24). In his letter to the Romans he outlines his theology. If one reads, absorbs and understands Paul's Letter to the Christians in Rome, then one has acquired quite a sound understanding of Christian theology.

In this final chapter of the letter, Paul sends greetings to several he knows in Rome.

He offers praise and gratitude to women and men who have rendered invaluable service in the work of the Gospel. The Apostle mentions five women in particular and for our case it will be helpful to look at each.

Phoebe stands at the very beginning of the letter: *I commend to you our sister Phoebe, a deacon of the church at Cenchrea, so that you may welcome her in the Lord, as fitting for the saints, and help her in whatever she may require from you, for she has been a benefactor of many and of myself as well* (16:1,2). Note the word above, 'benefactor', translated as such from the Greek **προστάτις** (prostatis) which is the feminine form.

Bruce Payne's excellent book[60] alerted me to the fact that 'benefactor' is really a rather dodgy translation and went on to explain

60 Philip B. Payne, *Man and Woman, One in Christ – An Exegetical and Theological Study of Paul's Letters* (Grand Rapids, Michigan, ePub Zondervan, 2015), 62 .

why, using the highly regarded Liddell and Scott's Greek-English Lexicon.[61] He writes that there are other, far more suitable words, if the Apostle had 'benefactor' in mind. I checked my own copy of Scott and Liddell and confirmed what 'prostatis' means: 'One who stands before, a front rank man (*author: or woman, when the feminine is used, as here*) (II) A chief, leader of a party (2) generally, a president, ruler. (III) One who stands before. A protector, guard, champion'. Payne makes a telling point. He writes that Luke uses a different word meaning 'benefactor,' 'those in authority over them are called benefactors εὐεργέται (euergetai) (Luke 22: 25). Thus, the linguistic evidence and the context of Phoebe's standing in the church strongly favour the normal meaning of the term, "prostatis" namely, "leader." Since her leadership was in the church it would entail spiritual oversight'.[62] If we accept Payne's explanation and what Liddell and Scott's Lexicon tells us; that the Greek word principally means 'leader' we can infer that Paul was probably once under the leadership of Phoebe.

Cenchrea, from where Phoebe came, was not far from Corinth. She had been given a letter by Paul to be delivered to the Church in Rome. As was the custom, she was issued with a special letter of introduction called a *sustatikai epistolai*.[63] We can assume that Paul did not think it was necessary to explain Phoebe's position as a deacon; only that she should be welcomed: '*... as is fitting for the saints*' (v.2). As 'saints' includes both genders it is reasonable to conclude that the early church regarded men and women to be equal in status. N.T. Wright comments: 'For Paul to trust her with a letter like this speaks volumes for the respect in which she was held; so it is no surprise to discover that she is a deacon in the church'.[64] Brendan Byrne states

61 Liddell and Scott, *An Intermediate Greek-English Lexicon (*Oxford: Clarendon Press, 1968), 698.

62 Philip B Payne, Man and Woman. 63

63 W.E Vine, Merrill F. Unger, and William White. *Vine's Complete Expository Dictionary of Old and New Testament Words*, (Nashville, Thomas Nelson, 1996) 751.

64 N.T. Wright, "Romans," in *New Interpreter's' Bible,* Volume X, (Nashville: Abingdon Press, 1994) 761.

that a significant number of people have judged Romans to be the most influential document in Christian history – and it was entrusted to a woman to deliver to Rome.[65]

Any suggestion that the word 'deacon' may refer simply to a church helper, which is one possible translation[66] has to deal with the fact that Paul himself used διάκονος (deacon) on a number of occasions to refer to his own ministry (1 Corinthians 3:5). It is interpreted variously through the NT as 'servant' and 'minister'. The NRSV has a subtitle (c): 'or minister'. '… it should be noted not only that this woman held a prominent position in the Cenchrean congregation, but that the word 'diakonos' is a masculine, not a feminine, form. Phoebe was a deacon, not a deaconess'[67] so we may infer that Phoebe held a position as a minister. In the early church, a deaconess did not preach but had more of a pastoral role. Byrne suggests that possibly Phoebe was a teacher or minister of that Church.[68] There is no evidence to suggest that his observation is incorrect.

Priscilla

Greet Prisca and Aquila, who work with me in Christ Jesus, and who risked their necks for my life, to whom not only I give thanks, but also all the churches of the Gentiles. Greet also the church in their house. (Romans 16:3-5a).

The first mentioned after Phoebe is Prisca (Priscilla) who is named before her husband Aquila (verses 3-4). The usual practice was to put the husband's name before his wife's. The inference is that Prisca has done more than her husband for the sake of the Gospel.[69] In fact, apart from the time where Paul meets Aquila for the first time, (Acts

65 Brendan Byrne, *Romans* (Collegeville, Minnesota: LTP, 1996), 448.
66 W.E. Vine, *Vine's Complete Expository Dictionary of Old and New Testament Words*, 147.
67 David H Stern, *Romans* Jewish New Testament Commentary (Clarksville, Md., Jewish New Testament Publications. 1992) 439.
68 Brendan Byrne, *Paul and the Christian Woman*, (Homebush, NSW: St Pauls, 1998), 70.
69 David H Stern, *Romans* Jewish New Testament Commentary (Clarksville, Md., Jewish New Testament Publications. 1992) 439

18:2), in the other five instances where the couple is mentioned in the New Testament, only once is Aquila mentioned before his wife (1 Cor. 16:19). Here in his letter to Rome, Paul steps away from the social norms of the day; another pointer to his positive perception of women. There is a wealth of information and queries contained in Paul's reference to Priscilla and Aquila, apart from putting her name first. How did they 'risk their necks'? (v.4). I doubt we'll ever know, for Paul doesn't elaborate. The couple however was widely known in the early church. When we turn to Acts 18:24-26, we learn of a man, a Jew, called Apollos, who became convinced that Jesus was the Messiah and began preaching 'boldly' in the Jewish synagogues ... *but when Priscilla and Aquila heard him, they took him aside and explained the Way of God to him more accurately.* (v.26b). Here is an undeniable fact: It was Priscilla who was the primary teacher. She's mentioned first. (What? A <u>woman</u> teaching a man? Well I never! According to more conservative Bible readers, that should not be!) Apollos went on to be a significant figure in the early church, for in his first letter to the Corinthians Paul wrote: *For when one says, 'I belong to Paul' and another, 'I belong to Apollos', are you not merely human? What then is Apollos? What then is Paul? I planted, Apollos watered, but God gave the growth.* (1 Cor. 3:4,5b,6). It was through the teaching of Priscilla and Aquila that Apollos became such a powerful leader and preacher in the early church. The couple also ran a successful house church (1 Corinthians 16:19) and Paul sent them all greetings. It was usually the women who ran the house churches.

Andronicus and Junia Paul writes, *They are prominent among the Apostles, and they were in Christ before I was'* (v.7). The perception that Junia was masculine, (a shorter form of Junianus) has long been abandoned and Junia is now universally regarded as feminine, and almost certainly the wife of Andronicus.[70] That Junia was a female apostle has staggering implications in regard to the question of perceptions of women's roles in the early church. (See the chapter JUNIA

70 F.F. Bruce, "Romans," in *Tyndale Complete Old and New Testament Commentaries* [CD ROM]. (Nottingham, Inter-Varsity Press, 1989).

included later. Learn more of her name and its see-saw travels though history. See to what lengths, including skulduggery, to which some went, in an attempt to ensure that Junia had a literary 'sex change', to become a male!)

While Paul was quite comfortable in regard to a woman's having apostolic authority, the ripple effect went out to all Christians of the early church, putting into practice what Paul had already written to the Galatians: 'There is no longer Jew or Greek, there is no longer slave or free, there is no longer male or female, for all of you are one in Christ Jesus.' (Galatians 3:28).

Mary, Tryphaena and Tryphosa, and Persis, The others who receive special mention are praised by Paul for their hard work in the Lord. While some may question the type of work the women did, Byrne notes that the word Paul uses for 'working' κοπιώσας

(kopiosas: labouring) is 'precisely the verb he uses to describe his own apostolic labours'[71] (Romans 16:12; 1 Cor. 15:10; Phil. 2:16). The evidence here is that they certainly weren't making cups of tea in the church hall, or setting out chairs for an evangelical meet! It strongly asserts that they were proclaiming the Word. Paul also sends greetings to several house-churches (verse 5 and others), almost certainly led by women

This section concerning Paul's perception of the role of women in the early church, and the majority of Christians of his day can be summed up in James D.G. Dunn's words: 'So far as the ministry of women in the Pauline churches is concerned, the position could hardly be clearer. Women were prominent in ministry. If we simply take the final chapter of our principal text, Romans 16, the point is made for us.'[72] His conclusion has wide support. Beverly Roberts Gaventa points out, 'Nothing in Paul's comments justifies the conclusion that

71 Brendan S.J. Byrne, *Paul and the Christian Woman*, (Collegeville, Mn Liturgical Press 1989) 73.

72 James D.G. Dunn, *The Theology of Paul the Apostle*, (Grand Rapids, Michigan: W.B. Eerdman's Pub, 1998), 586.

these women worked in ways that differed either in kind or in quantity from the ways in which men worked. Indeed, all of the individuals listed appear to be engaged in tasks of ministry, a fact that needs to be taken into account in any assessment of the roles of women in early Christianity'.[73]

We turn now to two other women, <u>Euodia and Syntyche</u>, mentioned by Paul in Philippians, 4:2,3, of whom Chrysostom (349-407) wrote, 'These women seem to me to be *the chief of the church* (my italics) that was there'.[74] Here we have perhaps the clearest evidence of all, of the leadership of women in the Early Church. Paul, probably in prison in Rome, writes, ... *help these women, for they have struggled beside me in the work of the Gospel, together with Clement and the rest of my co-workers, whose names are in the book of life.* Note 'co-workers' (NRSV). Paul uses the same word for 'co-workers' συνεργῶν (sunergn) that he uses when writing of Epaphroditus. (Phil. 2:25). '*Struggle*' *beside me*'. In Greek, the word is 'contended': συνήθλησάν (sunethlesan) to 'strive with' as in athletics.[75] Paul is obviously speaking of leadership positions.

Lydia, and other women

Sprinkled through Luke's record of the missionary journeys in the Acts of the Apostles, and Paul's letters, there are numerous attestations to the remarkable women who were to help take the burgeoning Christian Church forward, towards the first century.

In Acts, Luke records that Paul and his friends arrived at Philippi *... on the Sabbath day we went outside the gate by the river, where*

73 Beverly Roberts Gaventa, *Romans*, Women's Bible Commentary with Apocrypha, eds. Carol A. Newsom and Sharon H. Ringe, (Louisville, KY: John Knox Press, 1998), 320.

74 J. Chrysostom, 'Homily 13 on Philippians' Translated by John A. Broadus. From *Nicene and Post-Nicene Fathers, First Series, Vol. 13*. Edited by Philip Schaff. (Buffalo, NY: Christian Literature Publishing Co., 1889.) Revised and edited for New Advent by Kevin Knight. http://www.newadvent.org/fathers/230213.htm, accessed 1 April 2018.

75 W.E. Vine, *Vine's Complete Expository Dictionary of Old and New Testament Words*, 125.

we supposed there was a place of prayer; and we sat down and spoke to the women who had gathered there. Acts 16:13). The general rule in Judaism was that if there were at least ten Jewish adults in town, that was congregation enough (a minyan) to support a rabbi and to build a synagogue. Apparently Philippi was short on Jewish families at the time, for it seems there was no synagogue. 'It's an ill wind' and all that, so the Apostles took the opportunity to chat about the Good News to some ladies nearby. *A certain woman named Lydia, a worshipper of God, was listening to us ... The Lord opened her heart to listen eagerly to what was said by Paul.* (Acts 16:14). Lydia, who was a businesswoman; a seller of purple, was converted and baptised, and had her whole household baptised. Lydia was a generous person. After she first met the apostles she prevailed upon them to stay in her house in Philippi which they did (16:15,40). She was a prominent and influential lady, known as the first convert in Europe and obviously the one who established the Philippian congregation. Later Paul wrote to the congregation from his prison cell: *Therefore, my brothers and sisters, whom I love and long for, my joy and crown, stand firm in the Lord* (Philippians 4:1). Paul thanked the folk in the Church at Philippi for their generosity and kindness: *You Philippians indeed know that in the early days of the Gospel, when I left Macedonia, no church shared with me in the matter of giving and receiving, except you alone. For even when I was in Thessalonica, you sent me help for my needs more than once.* (Philippians 4:15,16). We can be certain that it was Lydia, the founder of that church, who was the initiator of the church's generosity.

Fact: It was Lydia, and obviously the women with her (Acts 16:13) who established the Philippian Church. On Paul's and the apostles' arrival in Philippi until they left (Acts 16:11-40) the only male mentioned in relation to conversion was the Philippian jailer, whose family also were all baptised (Acts 16:30-34), but Lydia is the proactive one who is mentioned several times, while the jailer, good man that he was, disappeared from scripture after that one incident.

Paul was strong in his support of the house churches, run by women. In his letter to the Colossians he wrote: *Give my greetings to the brothers and sisters in Laodicea, and to Nympha and the church in her house* (4:15). Lydia also had a house church, as did Priscilla and Aquila. The evidence seems to be that for the first couple of hundred years or so, Christians met in the homes of believers, so each congregation would be limited in size. There were no parish churches as there are today. Travelling Christians sought overnight accommodation in one another's homes, welcomed as belonging to the sacred Christian family of believers, which is one reason why Christians came to be known in the early church as the people of 'the Way'. (Acts 9:2 and others). When we speak of 'the family and household of faith' that's literally what they were. Those small communities, meeting in one another's homes became close and loving families in which in a special way they did become spiritual 'sisters and brothers' in Christ. One can imagine the intimate services of Holy Communion as the church family gathered around the table to take the bread and wine together.

How true would be the words of Fawcett's hymn:

Blest be the tie that binds
Our hearts in Jesus' love,
The fellowship of Christian minds
Is like to that above.[76]

In those days, when the women ran their houses, as they did in Old Testament times, they would certainly run many of the services. The evidence is that Lydia did. <u>Women were undoubtedly leaders in the Early Church</u>. The evidence shouts it.

76 John Fawcett, *Blest Be the Tie That Binds* The Scottish Psalter and Church Hymnary (Revised Edition) (London, Oxford University Press, 1929) Hymn 490

PAUL'S FIRST LETTER TO TIMOTHY:

Timothy 2:9-15

I permit no woman to teach or have authority over a man; she is to keep silent. (1 Tim.2:12).

We move into even deeper waters. Some may find this section hard to take, or understand, but work through it.

Paul's first and second letters to Timothy, as well as the letter to Titus, have been universally known as 'The Pastorals' since 1726. They are, perhaps, the most controversial books in the New Testament; especially in these later years, for the authenticity of the claimed author is widely debated to this day. According to the introduction to the Pastorals in the NRSV, the majority of New Testament scholars refer to the Pastorals as 'pseudepigraphical' (that is, written by someone else, under another's name; in this case, Paul's).[77] One problem I see is to do with Paul's complete change of attitude towards women. Romans, believed to be Paul's last letter, was written circa 57-59 CE. 1 Timothy, if genuinely Pauline, was written either about the same time, or at the very latest, 65 CE. How can Paul's attitude to women's having leadership roles change so dramatically in so brief a time? There is also a warmth in Romans 16:1-16 that is noticeably lacking in 1 Timothy 2:9-15. The New Testament scholar Marcus Borg writes, 'Though all three letters (that is, the Pastorals) claim to have been written by Paul, most modern scholars see them as written long after his death, in the first decades of the second century. There is a consensus that they were all written by the same person. But was that person Paul? For more than one reason, authorship by Paul is rejected'.[78] He then lists the reasons why scholars object to Pauline authorship and among them is the sudden, amazing shift from warm acceptance of women in leadership positions in Romans 16 to the inexplicable non-acceptance

77 Michael D. Coogan, ed., 'Introduction to Pastoral Epistles' in *The New Oxford Annotated Bible, with the Apocryphal /Deuterocanonical Books: New Revised Standard Version.* (Oxford: Oxford University Press, 2001), 349

78 Marcus J. Borg, *Evolution of the Word* (New York: HarperCollins, 1989), 563.

of women in leadership roles. 'The contrast to a particular passage in 1 Timothy 2:8-15 is stark ... The issue is not that women should pray and that women should dress modestly ... the issue is the different hierarchical roles assigned to men and women'.[79] Pauline authorship is defended by others. Others believe fragments are Pauline, but were added to by an unknown scribe. It's not for us to discuss in detail the ins and outs of why Paul's authorship is questioned here. I believe the Pastorals are Pauline - but I also suspect that somewhere along the line, a scribe (or scribes) has edited them heavily. Consider the fact that over the centuries before the invention of the printing press, hundreds and hundreds of pious monks and scribes wrote out copies of copies of copies of the New Testament by hand. It is known that some decided to have their say, and have added (or possibly even removed, accidentally or otherwise) bits and pieces. Other comments written in the margins by scribes (known as marginal gloss), have ended up in the writings. It's the work of numerous scholars to identify the additions but it's not always easy. Those who have serious doubts about Pauline authorship have based their findings under headings of historical, literary and theological criteria. Many subscribe the Pastorals to a later date; somewhere in the second century CE. 'Scholars have long debated whether these letters were written by Paul himself, or by a loyal disciple who sought to provide Pauline answers for new times and places'.[80] Professor W.J. Lowstuter supports that view. He writes, 'In doing this he (the purported unknown author) thought he was expressing accurately the apostle's mind. He was evidently quite familiar with Pauline thought and usage and, consciously or unconsciously, imitated or reproduced in striking measure the characteristics of the apostle. The practice and precedents of his age would fully

79 Ibid. 564.
80 Micahel D. Coogan, ed., 'Introduction to Pastoral Epistles' in The New Oxford Annotated Bible, with the Apocryphal /Deuterocanonical Books: New Revised Standard Version. (Oxford New York, Oxford University Press, 2001), Page 349

account for his so writing and justify him in doing it'[81]. One problem with Pauline authorship associated under the 'literary' heading is the use of language associated with a later date. Imagine you were reading a book, supposedly from Victorian times, (say, 1890) when suddenly you noticed words or phrases from a much later period - 1990 ... mention of 'laptop computers' or something. You would have to assume that it was not a genuine Victorian age document. Now that is a crude example, but I'm attempting to demonstrate why scholars make decisions based on literary reasons, known by biblical theologians and students of the Bible as 'textual criticism'. One historical consideration is that the writer mentions a number of places visited by Paul that tie in with visits made by Paul in other locations, in what scholars regard as the genuine Pauline letters. Lowstuter goes on to claim that the only way that Paul could have written the epistles would be if somehow he didn't die in the first wave of persecutions (as the early church unanimously testifies), but was freed, visited Ephesus, Troas, Miletus, Corinth, Crete and other places, during which he wrote 1 Timothy and Titus, was arrested again and wrote 2 Timothy while in prison. If that is so, it's unfortunate Paul didn't mention his early release from prison when writing 2 Timothy. The possibility outlined above has its supporters.[82] It's a little too 'iffy' for me. I'm suspicious of arguments presented from silence. Whatever way one looks at it, the Pastoral Letters present serious problems regarding authorship.

Scholars can tell the difference between something written a century or more after it was purported to have been written. In the world of two-thousand years ago, writing a document, then adding as the author some notable figure, was quite legitimate. It is almost certain for instance that the final verses of Mark's Gospel chapter 16 (9-20) were a second-century addition, which originally ended at verse 8. If

81 J. Lowstuter, "Pastoral Epistles: First and Second Timothy and Titus". edited by Frederick Carl Eiselen, *The Abingdon Bible Commentary* (New York, Abingdon Press, 1929),

82 Kenneth L. Barker and John R Kohlenberger III, *The Expositor's Bible Commentary New Testament* (Abridged Edition) (Grand Rapids Michigan: Zondervan, 1994), 889.

you have a look at your Bible you will probably see a reference to a later addition after verse 8. The reputed author of that was Aristion, of the early church.[83]

Byrne, supporting the theory of verses added to texts by others, writes, 'Apart from the ruling about the silence of women inserted into the text of 1 Corinthians 14, most of the bad reputation attaching to Paul in the question of women rests in the 'post-Pauline' letters'.[84] He believes that an unknown author added text to 1 Corinthians 14:34-36 to make it appear that Paul's perception of the role of women in the church agreed with the Pastorals' view. Byrne has a compelling argument to support his theory: he notes that Paul's expressed view in 1 Cor. 11:4 regarding the necessity of women 'who pray and prophesy,' must have their heads covered - is in contradiction to 14:34-36 which forbids women to speak in church.[85] If you think that people would not deliberately alter scripture to support a claim, I invite you to read a later chapter in this book concerning Junia, 'first woman apostle' mentioned by Paul in Romans 16:7).

Harking back to 1st Timothy 2:9-15, an impartial and scholarly work by professor (emeritus) Walter L. Liefeld gives us some new insights and as well, applies the text to the modern day. I have always questioned the contrast between Paul's ready acceptance of women in positions of authority in Romans 16:1-15, with 1 Timothy 2:9-15, purportedly written either about the same time or some years later. I mean, how could Paul, in so short a time, change his thoughts so drastically from unquestioning acceptance of women in leadership roles, to complete rejection? I still suspect that the passage from Timothy is an addition, but Liefeld doesn't. He accepts the Pastorals as genuinely Pauline, and fearlessly sets out to examine them. He looks at our text from every possible angle and examines all the significant Greek words. He believes Paul wrote the words in question – but also adds that the

83 G.A. Williamson, Translator: *Eusebius: The History of the Church* (footnote 1) p.150

84 Byrne, *Paul and the Christian Woman,* 81.

85 Ibid., 62.

Pastorals were written for their time, in a Greco-Roman age where women were subordinate, together with slaves. He does not believe those views should apply today. Without delving deeply into the argument as he expounds it, which would take a long time, let's cut to the quick. Liefeld writes, 'In the first century, Paul was willing to become 'all things to all people in order to save some'. (1 Corinthians 9:22). Would not the apostle think it inappropriate for us to forbid a female college student from teaching a Bible class composed of university students – men and women – when such a restriction could 'stumble' people and cause them to turn from the Gospel? A different kind of question often being asked today is whether it is right for a church to be deprived of the spiritual gift of leadership God may have given a woman when she is limited to using that gift in the women's group'.[86] Those refreshing words confirm the fact that despite his belief that Paul wrote the Pastorals as presented in the New Testament, Liefeld also believes that the apostle did not see his views as set in concrete; rather, the salvation of souls was the ultimate goal. Those who believe 1 Timothy 2:9-15 is inviolable have put legalism; (the authority of the words) above the Word, and are engaging in what some would call 'bibliolatry'. That the words of 1 Timothy 2:9-15 have caused some to stumble and fall away is without question, and many of us could name some. There has been a great deal of hurt over the years, among many women, who, upon reading this text, believe their dignity and worth as human beings is regarded by the church as second-rate. Rosemary Ruether writes, 'In his inaugural sermon in his home-town synagogue in Nazareth Jesus announces that he has come to 'bring good news to the poor, the liberation of the captives, the setting at liberty of those who are oppressed (Luke 4:18,19). In the outpouring of the Spirit at Pentecost slave women and men prophesy (Acts 2:18)'.[87] She goes on to write that the Letter to Timothy was written to give a

86 Walter Liefeld , '1 & 2 Timothy, Titus', in *The NIV Application Commentary: from Biblical text to contemporary life*. (Grand Rapids, Michigan: Zondervan, 1999) 112.

87 Rosemary Radford Ruether, 'Women in Christianity' *in Christianity: The Complete Guide*. John Bowden, ed, (London: Contiuum, 2005), 1220

definitive basis for women's continued subordination in the church 'and to refute any thought that this subordination has been changed by the redemption in Christ'.[88] No wonder many women find this very hurtful. In former times, women were regarded as child-bearers and raisers almost exclusively. Today, women are as well educated (frequently better so) than men; there are far more women than men in the pews in most churches; many have the gifts of preaching and teaching and feel a call to the ministry of Word and sacrament; have proved over and over again that they are capable – and yet in some denominations, the call is denied them. Loren Cunningham writes, 'When bias against women is perpetuated by Christians, the message it sends is that God is unjust. A woman of the past who felt this injustice was the famous nurse Florence Nightingale. Nightingale wanted to be a missionary, but there were no opportunities for her. She said, 'I would have given [the church] my head, my hand, my heart. She would not have them.'[89]

Yet another problem contained in 1 Tim 2:9-15, is a fixation by some on the requirement for women to 'learn in silence, with full submission' (v.11). Let's take the case of a deaconess in a hospice chapel, reading the Bible to a congregation that included dying people, some of them men, as I saw some time ago. Is she offending? Where does it end?

Women are not to wear gold or pearls or expensive clothes (v.10) – yet these days, most women in church wear a bit of gold somewhere, or display a gold ring or watch or bangle or a nice string of pearls, or a favourite pricey outfit, with a bit of lippy and/or rouge to top things off. Who notices? If they do, it's generally to think how nice she looks. I've yet to hear someone object on the grounds of Paul's directive in 1 Corinthians 11:5,6. In the same chapter, Paul writes that if a man has long hair, it is a disgrace to him. (1 Cor. 11:14). I wonder how

88 Ibid. 1231

89 Loren Hamilton Cunningham and David Joel, *Why Not Women? A Fresh Look at Scripture on Women in Missions, Ministry, and Leadership*, (U.S., YWAM Publishing, Kindle ebook, 2000) 198

many ministers started their ministries with long hair; or have long hair today? Does anyone notice if a man in the congregation has long hair? The point I am making in all this is the fact that the writer was writing for his day and age. None of those laws should apply today. I don't think they were meant to apply for all eternity. I don't think it would have crossed his mind. To turn such texts into inviolable laws is absurd. If people want to abide by the letter, they need to be consistent with all the above. Why have we introduced a law that isn't a law? '**I** desire...' (literally: '**I** want': Βούλομαι (boulomai), is the text of 1 Timothy 2:8, and the following verses are connected. That should not apply as a law to the Church universal down the ages. It's not a law – it's a personal view. Liefeld also notes that this is not a command. He writes, '... verse 12 contains no command. There is no imperative addressed to Timothy, to the women, or to the churches about women teaching or having authority'.[90] In fact you will find the same word, delivered in a personal statement written by Paul to the Christians in Philippi (Philippians 1:12 - NRSV): *I want you to know, beloved* ... boulomai -'I want' (my underlining). Again it's not written as a legal requirement. Paul is simply telling the Philippians that his imprisonment has enabled him and other Christians to take the Gospel to the Praetorian guards.

There is also something else about 1 Timothy 2:12 that served to convince Biblical scholars that Paul is possibly not the author of the Pastorals. It is a seemingly innocuous words, 'to have authority'. The word used in Greek is αὐθεντεῖν (authentein) which is translated in the NRSV: *I permit no woman to teach or to have authority* (authentein) *over a man; she is to keep silent*. Here's a mystery: It is the only time 'authentein' is ever used in the New Testament, and highly unlikely to be a word Paul used. It's a word familiar to classical Greek literature of a later period, where in the second and third centuries onwards, it was quite common, while virtually unknown in Paul's time. 'The αὐθέντ (authent) root words are typically strong and emotionally-laden words with negative or dominating overtones. The

90 Walter L Liefeld, '1 & 2 Timothy, Titus', 109

only meaning of αὐθεντέω (authenteo) that fits in 1 Tim 2:12 and is also established prior to Paul's day is 'assume authority.' 'To dominate' appears in literature shortly after Paul's time, but 'to have authority' or 'to exercise authority' are meanings that can be confirmed only much later in ecclesiastical writings.'[91] Payne quotes Wilshire who states that 'everywhere [else] in the NT where teaching and authority are mentioned together ... it is always the word ἐξουσία (exousia) that is the word used for 'authority'.[92] The word ἐξουσία simply means 'authority' and it is the word that Paul used in most cases. 'Authentein' is foreign in the NT except for that one suspect use in 1 Tim.2:12. Payne continues casting doubt on the Pauline authorship of 1 Timothy 2:12: 'It is also surprising, if Paul intended to exclude women from authority positions over men, that he specifically refers to women in his description of the requirements for deacons, listing their requirements for this office in 1 Tim 3:11. Furthermore, he introduces the requirements for an overseer by saying that anyone desiring the office of overseer desires a noble task, and nowhere in the requirements does he use a masculine pronoun'.[93]

While I believe Paul did write the Pastorals, surely that word 'Authentein' alone should convince most people, unless determined not to be convinced that 1 Timothy 2:9-15 is the work of an unknown scribe. Here's another problem:

... Yet she will be saved through childbearing, provided they continue in faith and love and holiness, with modesty. (1 Timothy 2:15) Note the change from singular to plural. It has been suggested that the writer means all women, not just Christian women, but I think it's more along the lines of a typo. The writer has in mind 'woman' as in Eve in the previous verse and really means 'women will be saved ...' More importantly, it must be pointed out that 1 Timothy 2:15 clashes with what lies at the very foundation of the Reformation; that salvation is by grace, through faith alone. (Ephesians 2:8,9). It is impossible to

91 Payne, *Man and Woman,* 363
92 Ibid. 365
93 Ibid. 378

imagine Paul's suggesting that God made an alternative arrangement for women. That point is also made by Joanna Dewey who writes, 'This passage is unique in suggesting that salvation for women is different from that of men. The rest of the New Testament is unanimous in making no distinction by gender, for men and women are also heirs of the gracious gift of life (1 Peter 3:7) ... The author of the Pastorals is urging conformity to the dominant pagan culture of the first and second centuries, while alternatives showing women's leadership go against those cultural norms'.[94] Dewey's comments here make sense if on the evidence we assume that the Pastorals were not written by Paul but were, according to the NRSV's introduction to the Pastoral Epistles, possibly written well after his death: 'The conclusion that these three epistles were not written by Paul is based upon literary, historical and theological criteria ... The literary evidence is based on the fact that the language in the Pastorals diverges in many ways from the rest of the Pauline epistles. Historically, the Pastoral epistles presume a situation marked by increasing institutionalization of the church and by heretical opposition, which perhaps better fits a period well after the death of Paul, at the beginning of the second century CE. Theologically, these minimize or lack characteristic Pauline themes (such as justification by faith, or the Church as the body of Christ)'.[95]

Benjamin Fiore has an interesting and intelligent view of just how the change from acceptance of women as preachers and teachers of both men and women during the time Paul wrote Romans, to some years later when the Pastorals were written. He writes that there was a marked shift in the perception of the role of women in the early church because several decades after Paul wrote his letter to the Romans, it was realised that the Parousia (the return of Christ) was not imminent: 'The Parousia is still awaited, but not with Paul's original

94 Joanna Dewey, *1 Timothy* The Women's Bible Commentary p. 356
95 The New Revised Standard Version of the Bible. *Introduction to the Pastoral Epistles*. Page 349

urgency. The long-term doctrinal stability and social standing of the community are the Pastoral Epistles' concerns'.[96]

He suggests that Paul's mission of teaching (going out to the whole world to spread the Gospel) changed in the intervening years between that time and the writing of the Pastorals. The Pastoral Epistles' theme is 'exhortation' – what Fiore calls the 'hortatory strategy' as the writer seeks to combat the 'false teaching' which was starting to spread among Christians.[97] If the Church was to be accepted, it had to fit in with the norms of the society of the day. The male head of the family in the secular Greco-Roman society of the day; the *pater-familias,* had all authority, so women who decades before had taught and prophesied and held places of authority in the church, were now not permitted to do so. As the second century church adopted the conservative standards of the Greco-Roman secular world, the role of women changed. The perception of the early church in regard to the role of women was untenable. The church felt it had a need to fit in with the current society if it was to succeed in its objective of winning the world, but to do so had to conform and so theology bent to the social convention of the day.

In Paul's day the early church believed that the latter days were at hand and the Parousia would dawn any day. Over time, those views changed. Pagans dominated the world's culture. It had become increasingly obvious that the Church in the new world had to find acceptance if it was to survive. Paul's acceptance of women in positions of authority, in a world whose own values were already clearly established, had angered those to whom his views were radical and unacceptable – as Jesus' radicalism had infuriated His enemies.

The women of the Christian Church became the losers in terms of what had been achieved in the first century CE. By the second century the perception of the role of women in the church had become

96 Benjamin Fiore, *The Pastoral Epistles, First Timothy, Second Timothy and Titus*, (Collegeville, Minn: Liturgical Press, 2009), 19.
97 Ibid.

the world's perception of what they should be, in the interests of 'propriety'.

If that is so, we have here a fascinating twist: *Those who oppose women having leadership roles in the Church are <u>actually supporting</u> the second century Greco-Roman anti-women in authority stance, while those who support women in leadership roles are supporting the Pauline position as in his Letter to the Romans*! Dwell on it.

THE FOUR PROPHETESS DAUGHTERS OF PHILIP
THE EVANGELIST

In Acts 21:8,9 Luke (the writer of Acts) records: *The next day we came to Caesarea and we went into the house of Philip the evangelist, one of the seven, and stayed with him. He had four unmarried daughters who had the gift of prophecy.*

Luke goes on to write (v.10) that Paul and the others stayed with Philip and the girls for several days. There is no indication that Paul was fazed by sharing Philip's house with four prophetesses – and neither would he be, for we've already shown that he had no problem with women who preached and prophesied. All the evidence suggests that Paul wrote to Christian communities that fully accepted men and women in leadership roles, as he did.

According to the historian Eusebius, (263-339 CE) Philip the Evangelist and his four prophetess daughters became very well-known in the Early Church, and the information concerning them gives more credence concerning the importance of women's leadership roles in the Early Church. Eusebius in Book 3 of his 'History' wrote, 'It has already been mentioned that Philip the Apostle resided at Hierapolis with his daughters: it must now be pointed out that their contemporary, Papias, tells how he heard a wonderful story from the lips of Philip's daughters. He describes the resurrection of a dead person in his own lifetime, (*named by Papias as the wife of Manaen: Williamson, page 151, footnote 2*) and a further miracle that happened to Justus, surnamed Barsabus, who swallowed a dangerous poison and by the grace of the Lord was none the worse'. [3.39.11][98]

Eusebius also wrote of the deaths of Philip and his daughters: 'In the *Dialogue* of Gaius of whom I spoke a little while ago, Proclus, with whom he was disputing, speaks thus about the deaths of Philip and his daughters, in agreement with the foregoing account: *After*

98 G.A. Williamson, (translator) *Eusebius: The History of the Church* (Harmondsworth, Middlesex, England, Penguin Classics, 1967) 151

him there were four prophetesses at Hierapolis in Asia, daughters of Philip. Their grave is there, as is their father's. [3.31.5].[99] He refers to Philip and his daughters as 'great luminaries' who shall rise again on the day of the Lord's advent. [6.24.8][100]

Eusebius gives a list of those who had prophesied under the New Covenant, in a polemic against the heretical sect, the Montanists, who prophesied while in states of ecstasy:

'But they cannot point to a single one of the prophets under either the Old Covenant or the New who was moved by the Spirit in this way – not Agabus or Judas or Silas or Philip's daughters ...' [6.17.1][101]

The evidence could not be clearer. Philip the Evangelist, mentioned by Luke in Acts 21:8 as the early church began to grow, continued to serve in faithful obedience as the Holy Spirit led them. Eusebius was obviously not the only one who knew of them. The daughters were known far and wide as prophetesses, deeply respected, mentioned in both life and in death.

99 Ibid. 141
100 Ibid. 231
101 Ibid. 222

JUNIA – FEMALE APOSTLE

Greet Andronicus and Junia, my relatives, who were in prison with me; they are prominent among the apostles, and they were in Christ before I was (Romans 16:7).

It is amazing to think how much debate can be produced over a single letter; in this case (in English), the letter S. It all has to do with the confusion of how the female apostle Junia came to be incorrectly (and even dishonestly) identified as a male, Junias; but now there is no denying it: Junia was female, and she was an apostle. The evidence not only suggests it – it demands it. Let's take a brief look at the history.

Professor Eldon Jay Epp writes, 'For the first seven centuries of the church's life Greek manuscripts did not employ accents, but when accents did become common practice in the manuscript tradition, and insofar as those accents can be identified, they uniformly identify the name (Junia) as feminine. To put the point sharply: there is no Greek manuscript extant that unambiguously identifies Andronicus's partner as a male. That consistent pattern coheres with the evidence offered by early Christian writers for the first thousand years of the church's life and well into the second thousand years'.[102]

Carmen Bernabé, a lecturer in New Testament at the Faculty of Theology of the University of Deusto, Bilbao and director of the Asociación Bíblica Española, writes, 'The majority of the interpreters (including John Chrysostom) maintain that it should be understood as inclusive: Andronicus and Junia belong to the group of the Apostles. Junia is thus called an apostle, precisely because she belongs to the group of the so-called 'Apostles'. Junia is a good example of how women with authority were rendered invisible and how their authority was reduced to the spheres and ways that men of every epoch deemed proper and consonant for women. These patterns had a crucial influ-

102 Eldon Jay Epp, *Junia: The First Woman Apostle*, (Minneapolis: Augsburg Fortress Press, 2005),44 Kindle edition.

ence at the moment of remembering and recording the past, an activity which, far from being purely anecdotal, is laden with the future'.

For over thirteen centuries Junia's feminine gender was never questioned.

From the late 13th century on, however, there were various attempts to change the female name Junia to a male name, Junias, because of the opposition some felt to having a woman as an apostle. The first attempt occurred in 1298 when Pope Boniface VIII instructed his secretary Aegidius, aka Giles of Rome, to give Junia a male name in the Greek manuscript copies. Giles fiddled with the Greek accent in Junia's name which turned Junia to Junias. Yet, writes Epp, the female Latin name Junia occurs more than 250 times in Greek and Latin inscriptions found in Rome, 'whereas the male name Junias is unattested anywhere'.[103] In other words, the name 'Junias' as a name was unknown at the time of the early church. 'Junias is a man who didn't exist with a name that didn't exist in the ancient world'.[104]

'In 1977 Bernadette Brooten, among many recent interpreters, summarized the matter forcibly, but aptly: 'To date not a single Greek or Latin inscription, not a single reference in ancient literature has been cited by any of the proponents of the Junias hypothesis. My own search for an attestation has also proved fruitless. This means that we do not have a single shred of evidence that the name Junias ever existed'.[105]

Regrettably, about two centuries after Giles cooked the books, Martin Luther also had a part to play in giving Junia what Professor Scot McKnight calls a 'sex-change'. Luther wrote, 'Andronicus and Junias were famous apostles' and were 'men of note among the apostles.'.[106] Right at the start of the Reformation, with Luther already

103 Eldon Jay Epp, *Junia: The First Woman Apostle*, (Minneapolis, Augsburg Fortress Press, Kindle ed. 2005). 696

104 Scot McKnight, *Junia Is Not Alone* (Colorado, Patheos Press, Kindle Edition 2011) 95.

105 Eldon, Jay Epp, *Junia: The First Woman Apostle,* Kindle Edition 587

106 McKnight, Scot, Junia Is Not Alone, Kindle Edition 102

a revered figure among millions as the Reformation swept through Europe, the damage to Junia was significant. It's a pity, for it was Luther who was given the Letter to the Romans to translate from Greek to German by his order, during his time as a Roman Catholic priest.

England was more fortunate. Before the renowned scholar William Tyndale went to the stake in Brussels in 1536, on the orders of King Henry VIII (he'd been in hiding in Europe) he translated the New Testament into English, circa 1527[107] – but didn't use a corrupted Greek manuscript. He used an original Greek version belonging to Desiderius Erasmus, a collector of ancient Greek manuscripts – which kept Junia as female. It made the English translations safe until close to the end of the 19th century. If you turn to your King James Version of the Bible (completed in 1611) and open it at Romans 16:7, you will see that it correctly translates the name as Junia. I am privileged to own an original, earlier version of the Bible, called The Geneva Bible, printed in 1610, gifted to me by Anna, a dear friend, so I was curious to see what it had to say about Romans 16:7. It reads, in the curious English of the day: *Salute Andronicus and Iunia, my coufins, and fellow prifoners, which are notable among the apoftles, and were in Chrift before me.* That text verifies what history tells us– the English translations kept the original female name – and verifies Junia as an apostle.

So how is it that centuries later, in the late 19th century, once again old Junias raised his hoary, virtual head? Patrick Mead, in the second of his two articles on Junia wrote, 'We can sum up the entire argument against Junia being a female by referencing just one scholar – Joseph Barber Lightfoot. As the 19th century became the 20th, he wrote in his notes on this text that Junia MUST be Junias, or male, 'because Paul called her/him an apostle and only men can be apostles'.[108] The

107 Marie Gentert King, *Foxe's Book of Martyrs,* ed. (New Jersey, Spire Books 1981) 170

108 Patrick Mead, "Who Killed Junia? Part 2", *The Junia Project,* May 2, 2014, accessed April 14, 2018, https://juniaproject.com/who-killed-junia-part-two/

bad news is that the honoured academic process, which should be completely impartial; called to convey the truth as the evidence dictates, became corrupted by something as sordid as an unwillingness to believe that a woman could be an apostle. The good news is, Truth will out – finally.

From 1927 into the 1990's, two editors of the Greek New Testament: Eberhard Nestle and his successor, Kurt Aland, changed Junia to Junias again, for no apparent reason – yet still the King James Version stuck solidly to the true translation. Almost all other translations went erroneously for 'Junias'. Have a glance at your Bible. If it's not a KJV, see if you are a Junia or a Junias. If it's pre-1990, it's almost bound to have Junias; the wrong name.

From the 1990's on, as it has become more and more obvious that there is no foundation whatsoever for a Junias to be in the New Testament, most Bible editors sacked Junias and reverted to 'Junia'. I doubt if you'll find a New Testament with 'Junias' in any Bible printed this century – except one. Among the last Bibles to change was the NIV, which made the swap back to Junia somewhere in 2011. I have an NIV printed in 1983 and noted that it has the name, Junias. In a sense it's historic, for it still retains that old ghost. I hope he never escapes again from there and neither should he, for he never really existed. The majority of the interpreters (including John Chrysostom in the comment cited above) maintain that Andronicus and Junia belong to the group of the Apostles. Junia is thus called an apostle, precisely because she belongs to the group of the so-called 'Apostles'.

WELCOME JUNIA – TAKE YOUR RIGHTFUL PLACE BESIDE YOUR HUSBAND AMONG THE REST OF THE APOSTLES OF THE EARLY CHURCH! CONGRATULATIONS!

PERPETUA AND FELICITA – MARTYRED SAINTS

During the persecutions under Nero and succeeding Roman emperors, thousands died hideous deaths; torn to pieces by wild beasts for the enjoyment of the crowds, burnt, crucified, dismembered, used as human torches to keep the streets alight at night. The more imaginative the minds of the torturers, the more the crowds loved it. It's difficult for us to understand the level of barbarity of those who tortured and murdered both the innocent and the guilty, and those who enjoyed watching the spectacles. Frequently, guilt lay in the particular religion of the victims. Rome had laws regarding religion. The authorities were reasonably happy for most people to stick to their own religions, for it kept them quiet, but there were exceptions. Those that the authorities believed posed no threat to the empire came under the category of *Religio Licita* (legal or permitted religion) and were fine. It was a different matter for those whose religion was classified as *Religio Illicita* (illegal religion). Adherents of religions which for one reason or another were considered a threat were in constant danger of a painful and prolonged death.

Between the years 193 -211 CE the Roman empire was ruled by Septimus Severus. During his reign he came to the conclusion that Christians were a threat to the empire, because they would not bow the knee to the emperor. They served a higher King, who had their first allegiance. Because of their obstinate refusal to acknowledge that the emperor was a god to be worshipped, Christianity was considered a *Religio Illicita.*

Severus decided on an ultimatum: All Roman subjects were forbidden to convert to Christianity. It was a case of emperor first – God second - otherwise make sure you've made out your will.

In the year 203 CE, Carthage, a province of Rome in North Africa, was a thriving and prosperous city with a large Christian community. In one of the churches, five catechumens (people doing a course for baptism) were preparing for the sacrament when word of the decree

of Septimus Severus arrived. Among the five was a young mother, Perpetua, aged twenty-one, who belonged to a noble family, and her maidservant, Felicita. They and the others - Revocatus, Saturninus and Secundulus - were arrested together with another Christian, Saturus, already baptised. Between arrest and imprisonment, the five were baptised.

Perpetua came from a mixed family. Her father was a pagan, but her mother and two brothers were Christian. Her family was desperate to save her, and her father begged Perpetua to recant. Her mother brought Perpetua's little boy to see his mother in prison, but she would not deny her faith.

Perpetetua was given to visions, and kept a daily journal, recording her imprisonment. One night in prison she had a vision of herself ascending a ladder, at the top of which were green pastures and still waters, as in Psalm 23, where sheep grazed peacefully. She interpreted the vision to mean that she would be martyred. Perpetua's father, wild with fear for his daughter and hearing a rumour that her trial and those of the others would be held soon, visited the dungeon where she and the others were being held, and begged her to recant; but Perpetua remained steadfast.

The following day the trial of the six confessing Christians took place, before the Procurator Hilarianus. All six confessed their Christian Faith. Perpetua's father brought his daughter's child to the trial, no doubt attempting to stir his daughter's maternal love to break down her will to continue in her faith. Even the judge had words with her, but to no avail. She refused to sacrifice to the gods for the safety of the emperor. The judge ordered Perpetua's father to be removed from the court, but the despairing man refused. He was forcibly removed with the aid of a whip. The accused Christians were then condemned to die by being torn to pieces by wild beasts. The Christians fell on their knees and thanked God.

The judge (procurator) advised them that they were to fight with wild beasts in the forthcoming military games.

Felicitas was eight months' pregnant at her trial and feared she would not be permitted to die a martyr alongside her beloved mistress, for the execution of pregnant women was forbidden. Two days before the Games were due to commence, she gave birth to a child; a daughter, which another Christian woman adopted.

The details of what was to follow were written down by a young Christian. On Thursday 7 March in the year 203, the Christians were led into the amphitheatre as the mob yelled excitedly. Wild animals were released, and the little band gave one another the Christian kiss of peace. The wild creatures, themselves victims in this vile spectacle, did not kill the Christians. When the mob jeered that the proceedings were a little slow, the five were slaughtered with the sword.

The feast day of Perpetua and Felicita is celebrated on 7 March each year and their names are included in the Calendar of Martyrs: 'The Philocalian calendar, i.e. the calendar of martyrs was venerated publicly in the fourth century at Rome. A magnificent basilica was afterwards erected over their tomb, the Basilica Majorum. That the tomb was indeed in this basilica has lately been proved by Pere Delattre, who discovered an ancient inscription, bearing the names of the martyrs'.[109]

Most importantly, their names, and the names of all the martyred saints, women and men, girls and boys, are in the Lamb's Book of Life, and their dwelling place is heaven.

Organised persecutions which began during the reign of Nero, continued spasmodically until the reign of the emperor Constantine, when persecution ceased; in fact his dear old mum was a Christian lady. Tradition tells us that Constantine was baptised a Christian on his deathbed, but he'd been sympathetic to the Christian faith long before that. Tradition also tells us that on the eve of the battle of Milvian

109 *The Catholic Encyclopedia* (1908; New Advent, 2009), CD-ROM.

Bridge on 28 October 312CE, he looked up at the sun and saw a cross of light above it, and around it these words: *In hoc signo, vinces!* ('In this sign, conquer!'). In 313CE he declared that the Christian faith did not pose a threat to the empire. By 380CE Christianity was the official religion of the empire.

A Final Thought

Here we must leave our stories of the Early Church. Let's offer a prayer, thanking God for the countless numbers of women as well as men, girls and boys, down the ages whose lives have been touched by the Holy Spirit; especially the martyrs. We thank Him for their priceless contribution to humanity in every generation. We thank Him for their witness to God's eternal purpose for His creation, shining as bright beacons in a dark world. We pray for the day when Christ shall return in power and glory; when the whole earth shall be redeemed; when sorrow and pain are gone; when love and righteousness shall reign for ever and ever. Amen.

PART 3
THE MODERN ERA

'OUR MOTHER IN FAITH'

THE REMARKABLE STORY OF MINNIE WATSON

The following is part of an article that appeared on 24 March 2017 in the Church of Scotland Website. Read this remarkable story of a Scottish missionary, Minnie Watson, (1867-1949) whose Spirit-led missionary activity changed the lives of countless numbers of women and men, girls and boys, and her work continues to inspire millions of people in Kenya. The Dundee-born teacher is still revered in the African nation, but she is virtually unknown in her homeland.

Minnie Watson was instrumental in laying the foundations of the Presbyterian Church of East Africa (PCEA) which today has around 3.5 million members. She dedicated more than thirty years of her life to spreading the Gospel in Kikuyu near Nairobi, and established a network of schools for girls and boys

One of Mrs Watson's pupils was Jomo Kenyatta who went on to become Kenya's first president – a remarkable student – and a male.

Her legacy is such that when Rev Robert Mbugua points to what is the first permanent church building in Kikuyu, he says: 'This place represents the foundation of where evangelism started in Kenya. Our roots are in Scotland so, because of that, this place is Scotland.'

PCEA Secretary General Peter Kariuki said: "Minnie Watson is our mother in faith. She is the image of Christ, and sacrificed all her comfort to live among our ancestors. She remains the icon of civilisation and genuine Christianity. We love our mother.'

Mrs Watson followed her fiancé, who was also from Dundee, to the former British colony in 1899 after he established the Scottish Mission in Kikuyu. They quickly married, but barely a year later he

died of pneumonia leaving his 32-year-old widow to assume responsibility for the project.

It was a world away from Dundee, and the daughter of a ship captain endured extreme hardship - drought, famine and disease - to fulfil her mission of spreading the Gospel.

Education and welfare was Mrs Watson's primary focus and she established an extensive network of Mission Schools for girls and boys.

Jomo Kenyatta, father of the current Kenyan President Uhuru Kenyatta, is a former pupil and was baptised in Watson-Scott Memorial Church. It was prefabricated in Scotland at the turn of the 20th century and shipped 7,150 miles to Kikuyu.

The Scottish Mission was originally funded by Christian directors of the Imperial East Africa Company but was taken over by the Church of Scotland twelve months after Mr Watson died.

Mrs Watson, who was head teacher of the Mission Schools system, was described by former pupils as an outstanding Christian role model - always loving, humble, patient but strict when necessary. She later retired to Dundee where she died in 1949 at the age of 82.

Here is another remarkable story of the way God calls women to achieve His purposes, and is more evidence of the way He values and blesses their work. Down the centuries there have been countless thousands of women who, like Minnie Watson, have been called by God to serve in some of the world's most dangerous and difficult places – and what's more – they are *still* serving! In light of stories like these, refusing to permit women to be ordained, or serve in leadership roles, appears to me to be flying in the face of what God wants for the salvation of the world. Women are part of His vast resource - often unused, undervalued, underestimated, ignored – even resented.

So often the work of our women in the service of the Master has gone unnoticed and unsung. If ever you go to the small town of Berry, in the Shoalhaven district of NSW, inland from the South Coast, find

the Presbyterian Church there and look for the brass plaque on the wall at the front of the church, which has these words:

In Memory of

MISS MARY McLEAN

Missionary in India for 31 years where

she served her Church in the cause of

Her Master with untiring ability and devotion

Born at Bolong NSW in 1860

Sailed for India in 1891

Resigned from service in 1923

Died on January 19th 1943

Prior to being sent abroad by the Women's

Missionary Association she was a member

of this Church and held the distinction of being

the first Australian-born Missionary from the

Presbyterian Church of New South Wales.

The final words on the plaque are: *She doth rest from her labours.* Those are words from the Book of Revelation, 14:13:

And I heard a voice from heaven saying, 'Write this: Blessed are the dead who from now on die in the Lord'. "Yes," says the Spirit, "They will rest from their labours, for their deeds follow them".

How fitting!

Set in the wall of this quiet little country church in Berry is sacred history: the plain, unadorned story of the NSW Presbyterian Church's first Australian-born overseas missionary – a woman, who left home and kindred to serve her Lord and Master for over three decades. Think of the lives Mary Mclean's ministry changed during those

years. How many have ever heard of her? That's a story we often hear of our women who serve so faithfully.

I was told of the plaque by Reverends Joy and Arnold Bartholomew. Rev Joy Bartholomew's father, Rev George Morrow, was ordained and inducted in that church after serving as a missionary in the Sudan.

THEOLOGIAN TINA BEATTIE

The Roman Catholic Church – the largest in Christendom – does not permit the ordination of women to the priesthood. Historically, it has never had women priests.

I would like to take the opportunity to include in this book a little of what is happening in the Roman Catholic Church, which has a large number of brilliant female theologians. So while women cannot be priests, the Church's theologians are making their presence felt in Rome; in fact all around the globe.

Some time ago, while engaged in other research, I had cause to contact Dr Tina Beattie, professor of Catholic Studies at Roehampton University, London. What makes her more interesting for Presbyterians particularly and protestants in general is the fact that she started life as a Presbyterian. Without doubt there are some in the Roman Catholic hierarchy who wish she'd remained Presbyterian, for she is very outspoken, and like so many Catholic theologians, female and male, is critical of the Church's refusal to budge on women's ordination to the priesthood. Her main areas of teaching and research are theologies and areas of gender; but her outspokenness, combined with parts of her theology regarded by some in the Church as radical, even heretical, are proving to be a thorn in the flesh of some English Catholic bishops.

While Beattie's general theology has not proved a problem within the Church, her continuing pressure on the Church regarding women's issues including her support for the ordination of women to the priesthood, has. In 2014 she wrote that she intended to commit the whole of the following year to raising questions about the absence of women's voices at the highest levels, including the exclusion from ordination. It's a question being addressed seriously by the Catholic Church: 'What was previously the bond to the mystery of origin is now regarded a discrimination against half of humanity…'

In an article titled 'What is Theology?' she states that she is 'a Catholic theologian with a feminist bias.' In that article she refers

to theologians in general as female: 'The theologian must give material expression to her use of the word 'God' in a way that counts as meaningful' which for her is in feminine terms.

She writes: 'Theology is at its best when it works in a triangular relationship with scripture, creation and culture, and is continuously asking how the texts and traditions of the Christian faith are to be interpreted in the light of the questions of our time.'

She also points out that theology has a significant place within secular study, because of its influence in western history and culture. She sees theology as a door that when opened, opens many other doors, and this whole book is based on that truth.

Beattie states that women have been silenced in the telling of history and their role has been marginal in the life of the Church; nonetheless they (women) are not alone. She quotes Isaiah 42:13,14 in which even God has been silenced, but He looks ahead to a new day dawning; a day of triumph. She adds a conciliatory note at the end of the paper, concluding that men as well as women are part of the maternal Church, 'called to live in peace and called to celebrate Christ's love in the fruits of the earth, and the kindness of friends, even in the face of danger and death.'

She reserves her loveliest language for the bride of Christ, (His Church) and Mary, and one cannot but be moved by those expressions that reveal her own deep faith. Her special love of Mary is particularly interesting in view of her Presbyterian background. Beattie writes, 'I am … aware of the deep differences that divide the Christian tradition, particularly with regard to the significance accorded to maternal feminine symbolism.'

In her Introduction in 'New Catholic Feminism' she writes, 'Until women are recognised as full and equal participants… graced with the image of God, capable of representing Christ to the world as fully and effectively as men do, the Church herself will continue to be a spiritual desert…' In that analogy, 'spiritual desert' it's possible to

discern a note almost of despair, and while other church communities do believe women capably represent Christ to the world as fully and effectively as men do, she wants her own, Catholic Church to recognise the contribution of women.

The slowness of response to the Catholic Church's petitions on the women's issue moved Beattie to criticise the Pope: 'He's conservative on sexual issues, but they all are,' she wrote - but, she added, 'Francis's personal experiences of, and commitment to, the marginalized might yet lead him to confront some of the issues that Benedict XVI was simply unable to grasp... Any Pope who listens to the poor and struggling people will hear women's voices if he really wants to. He has emphasised the maternal character of the church, and he says he wants a church in which the shepherds smell of the sheep. How about a maternal church in which the shepherds smell of bruised, hurting and dirty women dying in childbirth?' Beattie has a heart for the poor and oppressed, and it is revealed in much of her writing.

Beattie will continue to push the cause for women within the Catholic Church. Her theology is basically fundamental Christian, in accord with the teaching of her Church; although not all denominations would accept her feminist stance – certainly not conservative denominations.

While she has a deal of support, the present Church hierarchy, which has made some concessions, appears unwilling to 'drive the ship' at a faster rate of knots, which she and many other women in the Catholic Church, find stifling.

She writes that after World War 2, 'new voices emerged to challenge the dominance of the Western man of reason.

A contemporary of Beattie is Karen Armstrong, who trained as a nun but after seven years, left. Although a contemporary she is not now considered a Catholic theologian. In her book 'A History of God' she writes: 'Feminists are also repelled by a personal deity who, because of "his" gender, has been male since his tribal, pagan days.

Yet to talk of about "She" – other than in a dialectical way – can be just as limiting, since it confines the illimitable God to a purely human category.' Armstrong contributed to a feminist book edited by Ann Loades, which seeks 'a radical restructuring of thought and analysis which comes to terms with the reality that humanity consists of women and men... in other words, only half the story has been told.'

When Catholic feminist theologian Elisabeth Schussler Fiorenza was once interviewed she stated, 'The Bible is written in culturally and historically conditioned human language that is... grammatically androcentric... (centred on men) Theologians who insist that God is male... must also claim that it is divinely ordained that the majority of people are excluded from representing the Divine.'

There are other brilliant and determined female theologians like Tina Beattie, Karen Armstrong and Elisabeth Schussler Fiorenza who will continue to pursue the cause for Christian women to be eligible for ordination. The perceived decreasing number of men offering themselves for the priesthood within the Catholic Church may well work in their favour.

Other Catholic female theologians and those who are sympathetic to their cause will continue to work on those issues within the Church. A glance at the feminist section of any library indicates feminism within and without the Church is advancing rapidly and includes many brilliant scholars other than Beattie, Fiorenza and Armstrong.

Like reformers before her, Tina Beattie appears driven by a sense of injustice, and history supports her. In view of injustices women have suffered over centuries, a study of the attitudes of feminists becomes understandable.

For Protestant denominations that have women clergy, this chapter on an English Roman Catholic theologian, and the situation in Rome, may not seem relevant; however it's encouraging to think that the Roman Catholic Church hierarchy, which is so powerful, even with the drawbridges up and the walls manned, is being assailed from without,

by women, with some successes, and one can be certain they will keep plugging away, winning support. A long battle looms, for the Roman Catholic hierarchy is very conservative. Catherine Mayer writes that the Pope set up a special committee to examine the possibility of the Church's permitting women to become deacons. The Pope however is opposed to the ordination of women to the priesthood. He asserted that 'women look at life through their own eyes and we men cannot look at it in this way. The way of viewing a problem, of seeing things, is different in a women compared to a man ... We must not fall into the trap of feminism, because this would reduce the importance of a woman.' It seems a strange way to reject women's ordination, considering that vast numbers of women have successful ministries in many denominations. There are female bishops in Australia.

THE ICELANDIC MODEL

A woman, <u>Agnes M. Sigurðardóttir</u> is the bishop of all Iceland, (Evangelical Lutheran Church), which is the national church. The country ranks as the world's most gender-equal society as well as the most peaceful country; where forty per cent of the clergy are women.

The success in Iceland of gender equality was not always so. The struggle there was as long and as arduous as anywhere else. Those who sought it finally won the day. Catherine Mayer's book contains a vast amount of information. She and Sandi Toksvig, conceived the idea of creating a Women's Equality Party in the UK, in 2015, which is now up and running successfully. All people are welcome to join. Mayer has spent quite a lot of time in Iceland. In her book she writes, 'Once, a long time ago, when I visited Iceland, a woman called Drifa Snaedal talked to me about the problems her country still faced. 'Gender inequality is like a river', she said. 'You stop it here and it goes there. It finds its way – whether you're talking about the wages gap, or violence'. It seems that at one time, Iceland was much like the rest of the world but has overcome it.

The Christian Church globally is now facing more persecution than it has in the previous two thousand years. It is a time when we within the sacred community need to consolidate and use all the resources we have, as the Lord requires of us. 53% of the best resources are ready, willing and able to play their part: the women of the world-wide Church.

EARLY MEDICINE IN AUSTRALIA – A MEN'S CLUB

The following chapter was written by Squadron Leader Christine Dunn, a Commissioned Officer in the Reserve Forces of RAAF and a practising Medical Practitioner whose major interests include Genetics and Aviation medicine.

Christine agreed to submit the following paper when I asked her. She is a devout and practising Christian, with a mind that is far-reaching and wide in its scope. Outside her work, she has a special interest in theology, and at present is part-way through a Master of Theology degree. (See end of story for her post-nominals). This whole paper is a joy to read; thoroughly researched, beautifully told. I wish I had room for it all, rather than about fifty or so per cent, and I think that after you read this chapter, you'll be wishing that I had found the room.

.

In the early days of Australia's penal colony, the Crown provided almost all medical care through the salaried medical officers of the Colonial Medical Service. As the population of free settlers grew, there became a need for General Practitioners, most of whom were initially naval and military surgeons. Their successors were British-trained until three local universities were established around 1850. These graduates not only practised medicine but were highly active and vocal in political, cultural, commercial and pastoral developments. Between 1813 and 1860, thirty colonial medical students began their apprenticeships at the age of fourteen years with doctors in Sydney and Hobart and then travelled to Britain for examination to obtain a licence. Medical schools opened in Melbourne in 1862, Sydney in 1883 and Adelaide in 1885. Except for initial teething problems with hospital affiliation and egotistical attitudes, the schools flourished with male students. In 1885 Sydney University was the first to open admission to a woman student, Dr Dagmar Berne; however, due to

severe gender prejudice, she did not qualify, travelling instead to London to complete her studies, readily qualifying in 1893.

When Berne and her mother approached the Vice-Chancellor of the University, Sir Henry McLaurin for assistance, he refused, stating that no woman would graduate in medicine while he was Vice-Chancellor. In the ensuing ten years, Sydney University would produce only two women graduates.

The first woman to study at Adelaide University was Dr Laura Fowler, who was admitted in 1887 and graduated in 1891. Thirteen women graduated from Melbourne University during 1891-96, among them Dr Clara Stone, the first woman to be accepted onto the Australian Medical Register. In all, thirty-seven women, fourteen of whom were trained in Australia were registered to practise medicine in Australia between 1885-1900; however, their studies and career development were far from easy. The editor of the Australian Medical Journal wrote in 1860 '... a woman who voluntarily devotes herself to a state in which the abandonment of the domestic qualification seems a necessity, is a being whom men do not love and with whom women can hardly sympathise ...' These women graduates were denied residency posts in the major public hospitals due supposedly to lack of suitable accommodation for the ladies. In particular, in 1905 Dr Jessie Aspinall had been offered residency at the Royal Prince Alfred Hospital, however, the Conjoint Board refused to ratify the Hospital's decision, offering her place instead to the 17th and far less academically qualified male applicant. Similarly, Dr Susie O'Reilly was denied residency in Melbourne at three major hospitals due to her sex. Publication of these facts led to a public outcry, and she was instrumental through the Women's Progressive Organisation in breaking down the barriers to public practice.

At that time, women could only gain experience in private practice by working overseas, or volunteering at charity missions. Of equal concern were the observations that women in Melbourne were letting

their health degrade, due to their embarrassment to discuss personal issues with male doctors, and who were willing to see women doctors.

In 1896 the ten women doctors practising in Melbourne, under the inspiration and lead of Dr Constance Stone, decided to set up a hospital, and persuaded the Reverend David Egryn Jones to allow them to use space behind his Church. Here was established the Queen Victoria Hospital, hiring female administrators, pharmacists, dentists and setting up a predominantly female Board. Its work became extensively known as the 'family hospital' specialising in Obstetrics and Gynaecology, neonatal care, child psychiatry and research. This was the first Australian women's hospital.

MILITARY DOCTORS IN WW1

'WOMEN DOCTORS NEED NOT APPLY'

Not on one single occasion in the ANZAC Centenary celebration was a female medical practitioner mentioned as deserving of recognition for her service and devotion to duty for the lives of the men she saved and the country she served.

While much appears to be written about the struggle of women into professional employment over the past couple of centuries, and the accepted employment of women into the fields of nursing, teaching and politics, little appears to focus on the plight of women who wished to serve their Queen and Country as a doctor and, in particular, as a Military Medical Officer. In a war where nine million combatants and seven million civilians lost their lives, such ignorance and omission need to be rectified.

War was regarded as men's business. It was considered dirty, gory business in which no woman had a place nor was she wanted, in what was essentially a protected, closed male environment that gave men space away from females, who were too much of a distraction or 'were more trouble than they were worth'. Women were considered 'too illogical and hysterical' without the intellectual and mental capacity for leadership, and by extension, not fit to hold the King's Commission; that is, to be an Officer.

The first females involved in military roles was a small group of civilian nurses, sent to South Africa in the Boer War of 1899-1902. Following on from this, the Australian Army Nursing Service was established, serving in the various theatres during World War 1 under male command.

At the outbreak of the Great War, military traditions in Australia followed those of their ally, Britain, who had refused to entertain in any form, employment of women in the military hospitals or Medical

Corps, eventually conceding to involvement by volunteers in the Red Cross or other allied civilian occupation.

In the United States of America women doctors were rejected as suitable for enlistment, although they were permitted to work under civilian contract whenever a suitable male physician could not be found. Not only was their competence questioned, concern was expressed about the reactions of the men. As expressed by a colonel on the staff of the U.S. Surgeon-General, 'Such a position ... is not befitting a woman. There are obvious reasons why it is not desirable that they should be called upon to examine large numbers of men stripped to the skin ... from all classes of society, many of whom would not understand the precise position of the woman and think of her only as a woman.' Even Sir Winston Churchill in his capacity as Britain's First Lord of the Admiralty was sceptical, stating that command of Medical Field Units involved leadership and discipline which a woman would be equal to only in very exceptional cases. The authorities were happy for women to 'do their bit, go home and knit' as was told to Dr Agnes Bennett when she tried to enlist. She would go on to become the first female Commissioned Officer in the British Army.

At that time, across international military services, women's involvement in military medicine, except for the nurses, was devoid of rank, standing, opportunity for promotion, pension or disability benefits or post-war support of any kind. It was in this atmosphere of denial that those highly competent, educated and mostly affluent women would push the boundaries of prejudice to test the mettle of their resolve and that of military command. It was not unreasonable that Australian women doctors, like their British counterparts, would want to use their education, experience and skills to care for the wounded alongside those with whom they had studied and who had enlisted to do the same.

It would not be until 1940 after the outbreak of the Second World War that the first Australian woman doctor would be offered a commis-

sion in the Australian Army Medical Corps with the rank of Captain: Dr (Lady) Winifred MacKenzie, principally with administrative duties.

The Australian Women Doctors who served in World War 1

Against the background described above, 15 of the 129 female medical practitioners who were registered in Australia during the Great War would overcome significant barriers in order to travel to destinations such as England, France, Serbia, Egypt and Malta to serve. They would work as physicians, surgeons and pathologists for the British War Office, Royal Army Medical Corps, the Scottish Women's Hospitals and the War Office-funded London's Endell Street Military Hospital.

The Scottish Women's Hospital was founded by Dr Elsie Inglis, a persistent and determined Scottish doctor and campaigner for women's rights. When war broke out in 1914 she approached the British War Office and offered the services of the Hospital as part of the Royal Army Medical Corps. After her offer was rejected and she was told to 'go home and sit still', she and five Australian doctors working there established a 200-bed hospital at Royaumont 30kms north of Paris, to assist with casualties from the Western Front, eventually growing to a 600-bed unit by the conversion of a disused medieval abbey, situated there. Over the course of the war, the Scottish Women's Hospital manned 14 separate units across the war fronts. Foremost among the Australian doctors were:

Dr Agnes Bennett – Chief Medical Officer America Unit 4/Aug/16 -1/Sep/17
Dr Elsie Dalyell - Bacteriologist Royaumont 2/May/16 -2/Oct/16
Dr Mary Clementina De Garis - Chief Medical Officer America Unit 27/Feb/17 -30/Sep/18
Dr Lilian Violet Cooper - Doctor America Unit 1/Aug/16 -1/Sep/17
Dr Laura Margaret (Fowler) Hope - Doctor Kraguievatz 12/Sep/15 -12/Feb/16.

All those doctors received foreign decorations in recognition for their bravery and service, and all returned to practise in Australia in the post-war years - without recognition from Australia.

The dismal disinterest of the British military and the very great welcome expressed by the French Embassy, resulted in suffragists Dr Louisa Garrett Anderson and Dr Flora Murray setting up a hospital in the new Hotel Claridge in Paris in May 1915, staffed entirely by women and funded by private donations. No sooner had the doors opened than they received waves of upwards of 160 severe casualties from the front line, mostly under cover of night. Many of the wounded had lain untreated for several days and were septic or gangrenous. Such was the organisation and success of the Hospital and its sister unit at Wimereux, near Boulogne, that the British War Office recalled them to England, where they established the first female-run 500 bed military hospital, the London Endell Street Military Hospital, at an old workhouse in Bloomsbury. As it was close to rail lines and roads, it received wounded directly from France.

Although the War Office funded the Hospital and appointed Drs Anderson and Murray as 'Commanding Officers' and had a significant contingent of Australian women, their ranks were not commissioned and they could not wear official uniform, so they designed and pro-duced their own. Sadly, the RAMC viewed them as being attached on short contracts, and because of this they had no entitlements or benefits, as did the male officers.

Inconsistency and injustice, reflected in the formal histories of these women's service explains in part the lack of recognition. As described by what little remains of their personal accounts and their biographers, these women worked under the most horrendous conditions of weather, shelter, provisions, sanitation, equipment, discrimination and dissent, in order to fulfil their passion and what they perceived as their duty, risking not only their safety but also their own health, to improve what has been described as the most desperate of medical circumstances: war wounds and diseases in the men serving in the front lines.

When considering the factors that influenced the experiences of these exceptional pioneer women; the gender bias, prejudice against tertiary education, misogyny, restriction to practice and residential opportunity, lack of political and social influence and ignorance of intellectual abilities, I have come to understand and appreciate that the late 18th/early 19th century period ruled by Queen Victoria was one of class distinction overlaid by the strict morality and prudery of this monarch. Women were expected to behave with sensibility and decorum, be devoted to their men without encroaching on their territory or professions and to accept that education was necessary only for the purposes of being a wise woman, wife and mother, proficient at running a household. Medicine was a man's domain, as much because it was considered that women had neither the intelligence nor stamina to complete such a course of study in which many a man was found wanting, but also because the practice of medicine in that era was not a pleasant working environment. Scientific discovery was barely at the leading edge; penicillin had not yet been discovered, and much of medical diagnosis was done using only the 'senses' such as tasting urine and touching of body parts in physical examination. This, to some men, seemed repugnant and an undesirable quality in any woman who wished to participate in it. Men, however, were also highly protective of the power which their position and authority gave them in society, law and politics; particularly because women were encouraged to 'mind their place' and not be involved in the affairs of gentlemen, hence, the birth of the suffragette movement and the fight for equality and freedom to obtain education suitable to the ambitions these women desired.

The exploitation of the social constructs, gender discrimination, educational limitations, professional guardianship and military prejudice bring into sharp contrast the qualities of these women. In few other fields could women be so determined, persistent, courageous, passionate, tolerant, industrious, innovative and resourceful to the extent that they would use every means available and possible to achieve, not only their own goals but those of future generations. They would

change the tide of public opinion with regard to women's ability, and contribute to the limitation of morbidity and mortality during one of the most memorable military campaigns in world history.

Among Scott's final words on gender analysis, she asked: 'Why (and since when) have women been invisible as historical subjects, when did we know that they participated in the great and small events of human history? In addition, I have asked why have so few inquired into who were these 'invisible' women, that they might be acknowledged for their part in a great event in history.

It would be an interesting survey of the literature to learn more about the kind, supportive men who must have been present in the background of these women's lives in order for them to be educated and taught the fine art of medicine, if indeed men held all the power. Their part, too, should be acknowledged in their swim against the prevailing attitudes towards women.

Dr Christine Dunn
Bachelor of Science (ANU), Bachelor of Medicine and Surgery (NCL) Master of Translational Medicine (ANU)

POSTSCRIPT:

Thank you, Chris. All the hard work of women in the Australian Defence Force is at last starting to bear some fruit. At the 2018 ANZAC DAY Services across Australia, women Defence Force personnel and civilians had the task of leading the march – for the very first time!

A CASE OF (SUB) ORDINATION

In March 2018 an article titled *The (Almost) Free Work of Sisters,* written by prominent Italian journalist Marie Lucille Kubacki, appeared in the Italian Magazine, *L'Osservatore Romano*. The article, under the section 'Women Church' which has a regular series on women's issues, is a condemnation of the menial work sisters have to do, for almost no remuneration, working as servants for male clergy – mainly cardinals, bishops and priests. The sisters are expected to work, preparing meals, washing, ironing, cleaning, from early morning until late at night, mostly at the beck and call of those they serve.

One of the sisters told Ms Kubacki that she was saddened by the fact that, even although the sisters were consecrated people, as are the priests, it was rare to be invited to join the priest at the table she'd prepared, and to enjoy in his company the meal she'd made. Usually she ate alone in the kitchen. Ms Kubacki wrote that a Roman journalist who is concerned with religious news even nicknamed the sisters 'Pizza Sisters', to reflect the work they were expected to do. Most of the sisters are very well educated, and even those who have senior degrees as high as doctorates are given menial roles.

One of the sisters told Ms Kubacki that behind all this sad scenario lies the assumption that women are worth less than men; that the priest is everything and the sister is nothing in the Church. 'Clericalism is killing the Church' the sister told Ms Kubacki. Here we are listening to an age-old story.

Sadly, the article bears out an undeniable fact, that in this world, one section of humanity is regarded by the other as of less value. The level of servitude expected of the sisters has no scriptural backing, but passages such as 1 Timothy 2:9-15 have an unfortunate influence on the subconscious mind of society, in which even many women accept the fact that they are not permitted to fill

roles that they would be quite capable of doing as well as males. They believe their subordination is God's will. It's a fact however that fallen human nature historically seeks the route that provides best for its own personal comfort and welfare, to the detriment of women – unless the Holy Spirit intervenes.

Meanwhile, in the secular world, Catherine Mayer has many statistics to support her claims for women in her book, 'Attack of the 50ft Women'. Hers is a secular book but it seeks to highlight the problems women face and to provide a way in which the dignity and worth of women can be enhanced. She is aware that when women are regarded as lesser creatures, there is a follow-on effect into all areas of life. The recently-formed Women's Equality Party in the UK and now in the USA was formed to give women a voice– and more clout. Mayer refers to the gender wage gap in developed countries. In this regard it is worth noting the most recent (2016) gender wage gaps reported by the Organisation for Economic Cooperation and Development (OECD). The percentage gap between women's and men's earnings is 16.8 in the UK, 18.1 in the USA and 14.3 per cent in Australia. She quotes Laura Cohn in *Fortune* magazine who gives the reason for the gap: 'job segregation and discrimination'. Mayer has stories, some depressing, some tragic, of male domination. Among the many she researched, she discovered that male nurses in the USA earn an average of $5,100 more in salaries than female nurses, for the same work. In China a man who murdered a woman he'd abused for years, received a lesser sentence because she was his wife. And on and on it goes. Mayer has many examples, but in truth there are far too many to be recounted here.

So how are Christians to live in a world where statistically, women are regarded as lesser creatures? You may recall that earlier in this book we talked about the Greco-Roman world in which women were subordinate, and worse, and that certain sections of the Christian faith also believe that God requires women to be subordinate.

Paul, as was demonstrated in Romans 16 and other places, believed women and men to be of equal worth, in every way. He had no problems with women leaders in the early church. In his letter to the Ephesian Church Paul wrote, *You were dead through the trespasses and sins in which you once lived, following the course of this world* ... (Ephesians 2:1,2). 'The course of this world' is life outside what God requires of His people. For Paul, 'this world' frequently had satanic undertones. Before we can have our faith truly perfected, Christians are called to live a life with values different from the world's. Paul told us that we are not to let ourselves be conformed to this world, but *transformed*, by the <u>renewing</u> of our minds (Romans 12:1); made new by the One Who makes all things new. (Revelation 21:5). We are to be 'in the world, not of the world' so while we can and should enjoy all that God in His goodness has given us in this beautiful world, we are to live life in the Spirit, which is different from the way the world looks at life. We are to honour those whom God honours, and God certainly honours and blesses women in equal portions to men.

As indicated in the Genesis story at the beginning of this book, a world in which more than half the population is regarded as second-best is not the world that God wants it to be.

I read an article some time ago in which the writer claimed that Galatians 3:28: *There is no longer Jew or Greek, there is no longer slave or free, there is no longer male or female, for all of you are one in Christ Jesus* was over-used. I believe that this text is not used often enough.

PART 4
ONE FINAL WORD

The year 2017 marked the 500th anniversary of the Reformation, which was built on a text from Paul's Letter to the Romans. As Martin Luther translated the Greek text into German, a verse sprang out of the page at him that was eventually to change the world: ὁ δὲ δίκαιός ἐκ πίστεως ζήσετα. *But the righteous shall live by faith.* (Romans 1:17). It is by faith – not legalism - in the leading of the Holy Spirit that we need to accept the worth of women in preaching and teaching roles; quite apart, first, from the undeniable scriptural evidence contained in this book and second, the remarkable witness of women down the ages; in the early church - in mission fields and in countless other areas of service as well as in many denominations - serving in leadership roles. We don't have to live by what the Greco-Roman world of 2,000 years ago considered to be the place of women.

So, how big is our God? Is it possible that the 'God of the galaxies' - Creator of the whole universe - has set aside only men to proclaim his Word and have leadership roles, while denying 53% of humanity a possible Call to a leading role in the Body of Christ? Is it possible to *confine* the Holy Spirit? The free Spirit of the Creator of the universe rises far, far beyond such trivialities, to choose whom He will – male or female – in the urgent task of spreading His Word all over the world, to save people, to prepare us for the end of days or even the end of life. We await the Lord's promised return, or our destiny, whenever that may be.

The Holy Spirit speaks to the Church of today, and to the world, pushing for humanity to change. When the writer of 1 Timothy penned his lines, he was writing for the situation of the church in his own day and age – but not to the Church in all generations. It was a personal letter, expressing a personal view. It never would have occurred to him that those same words would be held over the heads of some of the Christian Churches two thousand years later, as *nunquam mutandas*

– never to be altered. I doubt if ever he thought so far ahead. In fact, it's highly likely he imagined that the Parousia (the return of Christ) would have occurred within a few short years.

If this book was a courtroom, and a jury was asked to sum up the evidence presented herein and to make a decision for or against that woman standing in the dock, the decision would be unanimous: 'The case in your favour is proved beyond reasonable doubt.' It would be a matter of weighing up the evidence in the few short texts we have in the pastoral and Pauline letters – so few in number – against the whole weight of evidence we find in the rest of the Bible.

Look at the Church of today compared to the Church of two thousand years ago. We can be faithful to the Lord in all that He calls us as His people to do; to be in the world (we have no option); but simply not of the world, in what the world prizes, much of which we see as dross. We are called to live by faith, as God's righteous people, as Paul wrote. We live by faith, not the Law, for the old Law has gone and the new life in Christ has come. Few women today wear hats in church – none is obliged to. No one blinks if a man has long hair. Women wear smart clothes and sport gold and jewellery. No one notices now because it's not important any more. Women teach boys and girls in Sunday schools and schools. Women preach. Women stand up in committees and give their views. Women vote for or against ministers where there is a Call system operating in a denomination. They serve on committees. Where would the Church of today be without them? They're in the vast majority in the pews and do most of the jobs in most churches.

The Holy Spirit cannot be tied down to what worked in the Church almost two thousand years ago; in fact the Holy Spirit, the Lord and giver of life, won't be tied down at all. If the Church won't listen, the Holy Spirit will bypass it and move on to those more receptive to His voice. In Paul's time, slavery was a simple fact of life. Paul accepted that fact. In his Letter to Philemon, he suggests to Philemon that Philemon's runaway slave, Onesimus, whom Paul is returning to his

master, should be regarded as a brother in Christ, and the suggestion there is that Philemon should release him – but Paul doesn't say that all slaves should be released. (Philemon 12-17). In Ephesians 6:5-8, he calls on slaves to obey their masters and calls on masters to treat their slaves well (6:9). Slavery in our society has been abolished for hundreds of years. Those texts applied back then but they don't apply in 21ˢᵗ century western culture. We are being called to move on; to be relevant to people in our day and age – yet at the same time, stand apart from the world in matters of commitment to and faith in God; to challenge the world and to witness to the world. We live in the joyful light of the One Who is the Lord of Life, Who tells us that He has come, that we may have life, in all its abundance (John 10:10). That's what sets the Church apart from the world; the deep richness of life lived in the joy of faith in Christ. That's what attracts people who are sick of the tawdry tinsel bits and pieces that world offers, with its sordid moral standards. I was standing on Central Station recently when a lady passed by, wearing a T-shirt with a message: *Everything's Amazing. No one is happy*. It's true, if happiness is seen as material. True happiness is spiritual. Great wealth, possessions, entertainment, leisure, boys' toys various, will never bring lasting happiness. When Christ calls us to be transformed from within, the old has passed away – the new has come. We don't have to be concerned with outward rules relevant to another age, for the righteous live by faith. We don't have to live by Greco-Roman laws of two millennia ago.

In the closing pages of his book, Professor Philip Payne makes a final, telling statement that sums up perfectly the true situation in regard to women's holding leadership position within the Christian Church: 'The totality of the Scriptures' affirmations of women leading God's people is inescapable. To maintain the view that women must never teach or have authority over men, one must demonstrate that, given the entirety of the scriptural evidence, it is improbable that God ever authorized a woman to teach or to have authority over a man. Yet the biblical evidence against this is as strong as an avalanche'.

I believe God made us to be equal in everything. Women and men are to share in the sense of worth and dignity for which our Creator God made us, and to honour Him.

Let me leave you with this thought: The role of Christians is to bear witness to the life, death, resurrection and ascension of Jesus Christ – the Paschal Mystery - and the gift of the Holy Spirit at Pentecost. Everything else is subject to that. **In light of what has been written in this book, do you REALLY believe that over half of all humanity is forbidden by God to carry the message of salvation to the other half?**

I'm sure this book won't be around in another two thousand years; in fact it's my prayerful hope that the Parousia will occur in my lifetime, as I reflect on John's closing words in the Book of Revelation, 22:20,21; the last book in the Holy Bible and its last beautiful lines: *The One who testifies to these things says, 'Surely I am coming soon'. Amen! Come, Lord Jesus! The grace of the Lord Jesus Christ be with all the saints. Amen.*

And I say: Amen. Amen. Amen.

BIBLIOGRAPHY

Armstrong, Karen. *A History of God*. London: Mandarin, 1993.

Barclay, William. *The Gospel of John, Volume 2*. Philadelphia, The Westminster Press, 1975.

Barrett, C. K. *The Pastoral Epistles in the New English Bible*. Oxford: Clarendon Press, 1963.

Beattie, Tina. "Pope Francis has done little to improve women's lives." *The Guardian*, Aug 27, 2014. https://www.theguardian.com/global-development/poverty-matters/2014/aug/27/pope-francis-womens-lives-catholic-church

Beattie, Tina. *The New Atheists: The Twilight of Reason and the War on Religion*. London: Darton, Longman & Todd, 2007.

Beattie, Tina. "Towards the Future in Hope: Women remaking the Church." Lecture at Andante Summer School, Kloster Reute, August 27 2011.

Beattie, Tina, "Religious Identity and the Ethics of Representation." *In Gender, Religion and Diversity: Cross-Cultural Perspectives*, edited by Usula King and Tina Beattie, 65-78. London [England]: Continuum, 2005.

Beattie, Tina. *New Catholic Feminism: Theology, Gender Theory and Dialogue*. Abingdon: Oxon. Routledge, 2006.

Beattie, Tina, "A bulwark against ignorance." The Guardian, May 24, 2010. https://www.theguardian.com/commentisfree/belief/2010/may/24/theology-religion-philosophy

Bernabé, Carmen. "Junias the Apostle: Paul and women." *L'Osservatore Romano,* March 1, 2018. http://www.osservatoreromano.va/en/news/junias-apostle.

Borg, Marcus J. *Evolution of the Word: The New Testament in the Order the Books Were Written*. New York: HarperOne, 2012.

Bruce, F.F. "Romans." In Tyndale Complete Old and New Testament Commentaries [CD ROM]. Nottingham, Inter-Varsity Press, 1989.

Byrne, Brendan. *Romans*. Collegeville, Minn: Liturgical Press, 1996.

Byrne, Brendan. *Paul and the Christian Woman*. Collegeville, Minn: Liturgical Press, 1988

Camp, Claudia V. "1 and 2 Kings." In *The Women's Bible Commentary*, edited by Carol A Newsome and Sharon H Ring. (109) Louisville: Westminster John Knox, 1998.

The Catholic Encyclopedia: Articles transcribed from The Catholic Encyclopedia: an International Work of Reference on the Constitution, Doctrine, Discipline and History of the Catholic Church, Appleton, 1907-1912. Denver, CO.: New Advent, 2009. CD-ROM.

Catholic Women's Ordination. *Challenging Institutional Sexism in the Roman Catholic Church*

E-news, October 2014, issue 75. http://www.catholic-womens-ordination.org.uk/cutenews/data/2014/Enews1410.pdf

Chrysostom, J.'Homily 13 on Philippians' Translated by John A. Broadus. From *Nicene and Post-Nicene Fathers, First Series, Vol. 13.* Edited by Philip Schaff. (Buffalo, NY: Christian Literature Publishing Co., 1889.) Revised and edited for New Advent by Kevin Knight. http://www.newadvent.org/fathers/230213.htm.

Congregation for the Doctrine of the Faith, *From "Inter Insigniores" to "Ordinatio Sacerdotalis" Documents and Commentaries,* (Washington, D.C.: United States Catholic Conference, 1996).

Coogan, Michael, ed.*The New Oxford Annotated* Bible: *With the Apocryphal / Deuterocanonical Books: New Revised Standard Version.* Oxford, New York: Oxford University Press, 2001.

Crossway Bibles. *The Holy Bible: English Standard Version Containing the Old and New Testaments* Wheaton, Illinois : Crossway, 2001.

Cunningham, Loren; Hamilton, David Joel, Rogers. *Why Not Women: A fresh look at Scripture on Women in Missions, Ministry and Leadership.* (Seattle, Wash: YWAM Pub, 2000). Kindle Edition.

Dewey, Joanna. "1 Timothy." In *The Women's Bible Commentary : Expanded Edition with Apocrypha, edited by* Sharon H Ringe., and Carol A. Newsom, 442-449. Louisville: Westminster John Knox, 1998.

Daly, R, 'Adelphoi', *Biblical Language Research: Grammatical, Lexical and Historical Studies of the Hebrew text, Septuagint and Greek texts of scripture; especially as they relate to correctly explaining and translating the sacred writing,* April 12, 2011, http://biblicallanguagesresearch.blogspot.com.au/2011/04/adelphoi.html.

Douglas J.D, ed., "Mary." *The New Bible Dictionary.* London: Intervarsity Press 1975.

Dunn, James D. G. *The Theology of Paul the Apostle.* Grand Rapids, Mich: W.B. Eerdmans 1998

Eiselen Frederick Carl, ed. *The Abingdon Bible Commentary.* New York: Abingdon Press, 1929.

Epp, Eldon Jay. *Junia: The First Woman Apostle.* Minneapolis: Fortress Press 2005. Kindle

Eusebius, G. A. Williamson, *The History of the Church from Christ to Constantine.* London: Penguin Classics, 1968.

Fiore, Benjamin, and Daniel J. Harrington. *The Pastoral Epistles: First Timothy, Second Timothy, Titus.* Collegeville, Minn: Liturgical Press, 2007.

Freeman, Tzvi, 'What is Tzaddik?' *Chabad.org,* accessed March 20, 2018, https://www.chabad.org/library/article_cdo/aid/2367724/jewish/Tzaddik.htm

Frymer-Kensky, Tikva, " Sarah/Sarai: Bible" *Jewish Women's Archive Encyclopedia,* accessed March 28, 2018, https://jwa.org/encyclopedia/article/sarahsa-rai-bible.

Gaffey, Conor, "Tina Beattie criticises 'lack of dialogue' after event is cancelled", *Catholic Herald,* 26 Sep, 2014. http://catholicherald.co.uk/news/2014/09/26/tina-beattie-criticises-lack-of-dialogue-after-being-banned-from-event/

Gaventa, Beverly Roberts. 'Romans.' In *The Women's Bible Commentary : Expanded Edition with Apocrypha,* edited by Sharon H Ringe., and Carol A. Newsom, (320) Louisville: Westminster John Knox, 1998.

Hirsch, Emil G. Wilhelm Bacher, Jacob Zallel Lauterbach, Joseph Jacobs, Mary W. Montgomery. "Sarah" *The Jewish Encyclopedia,* accessed 20 Februrary 2018, http://www.jewishencyclopedia.com/articles/13194-sarah-sarai

JewishEncyclopedia.com. JewishEncyclopedia.com: The unedited full-text of the 1906 Jewish Encyclopedia. Wynnewood, PA: Kopelman Foundation. http://www.jewishencyclopedia.com/

Kadari, Tamar, "Abigail: Midrash and Aggadah," *Jewish Women's Archive Encyclopedia,* accessed March 28, 2018, https://jwa.org/encyclopedia/article/abigail-midrash-and-aggadah

Kadari, Tamar, "Sarah: Midrash and Aggadah" *Jewish Women's Archive Encyclopedia,* accessed March 28, 2018, https://jwa.org/encyclopedia/article/sarah-midrash-and-aggadah

Kidner, Derek. "Genesis." In Tyndale Complete Old and New Testament Commentaries [CD ROM]. Nottingham: Inter-Varsity Press, 1989.

Marie Gentert King, ed., *Foxe's Book of Martyrs.* New Jersey: Spire Books, 1981.

Knight, George A.F. *A Christian Theology of the Old Testament* London: SCM Press Ltd., 1964.

Norton, Michael Barnes. 'An Interview with Elisabeth Schüssler Fiorenza "Critical Reflections on Philosophy and Theology." '*Journal of Philosophy & Scripture,* 1, no. 2 (Spring 2004), accessed February 1, 2018, http://www.philosophyand-scripture.org/ElisabethSchusslerFiorenza.pdf.

Liddell, Henry George, and Robert Scott. A Intermediate Greek-English Lexicon. Oxford: Clarendon Press, 1968.

Liefeld, Walter L, "1 & 2 Timothy, Titus." In *The NIV Application Commentary: from biblical text to contemporary life.* Grand Rapids: Michigan, Zondervan, 1999 .

Loades, Ann, ed., *Feminist Theology: A Reader.* London, SPCK, 1993.

Mayer, Catherine. *Attack of the 50ft Women – How gender equality can save the world*. London: Harper Collins, 2017.

Mead, Patrick. "Who Killed Junia? Part 2." *The Junia Project,* May 2, 2014, accessed April 14, 2018, https://juniaproject.com/who-killed-junia-part-two/

McKnight, Scot. *Junia Is Not Alone* Colorado: Patheos Press , 2011. Kindle Edition

Mowczko, Marg. "What's in a name? Deborah, woman of Laippidoth." *Marg Mowczko: Exploring the biblical theology of Christian Egalitarianism*, 2015, accessed 1 April, 2018, https://margmowczko.com/deborah-woman-of-lappi-doth/

Mowczko, Marg, "Huldah's Public Prophetic Ministry." *Marg Mowczko: Exploring the biblical theology of Christian Egalitarianism*, 2018, accessed 1 April, 2018, https://margmowczko.com/huldah-prophetess/

O'Day, Gail R. "John." *The Women's Bible Commentary*, edited by Carol A Newsom and Sharon H. Ringe, (298-299). London: SPCK 1992

OECD Data: Gender Wage Gap. https://data.oecd.org/earnwage/gender-wage-gap.htm

Osiek, Carolyn, and David L. Balch. *Families in the New Testament World: Households and House Churches*. Louisville: Westminster/John Knox press, 1997.

Payne, Philip Barton. *Man and Woman, One in Christ: An Exegetical and Theological Study of Paul's Letters*. Grand Rapids, MI.: Zondervan, 2009, Kindle

Ruether, Rosemary Radford. "Women in Christianity." In *Christianity: The Complete Guide*, edited by John Bowden (1220), London: Contiuum, 2005.

Scholer, David M, "1 Timothy 2-8-15 and the Place of Women in the Church's Ministry." In *A Feminist Companion Deutero-Pauline Epistles*, edited by Amy-Jill Levine and Marianne Blickenstaff, 98-121. London, T&T Clark International, 2003.

Scottish Women's Hospital, The: https://sites.google.com/site/archoevidence/home/ww1australianwomen/scottish-womens-hospital

Sloane, Andrew, *At Home In A Strange Land. Using the Old Testament in Christian Ethics*, Grand Rapids: Baker Academics 2008, Kindle Edition

Sloane, Andrew, ed., *Tamar's Tears. Evangelical Engagements with Feminists Old Testament Hermeneutics*. Eugene, Oregan: Pickwick Publications, and Imprint of Wipf and Stock Publishers, 2012. Kindle.

Stern David H, trans. *Complete Jewish Bible Translation*, Clarksville MD: Jewish New Testament Publications, 1998.

Stewart, L. Australian Defence Force, http://www.womenaustralia.info/leaders/biogs/WLE0338b.htm

Vine, W. E., Merrill F. Unger, and William White. *Vine's Complete Expository Dictionary of Old and New Testament Words: With Topical Index*. Nashville: T. Nelson, 1996.

Weatherhead, Leslie D. *Personalities of the Passion.* London: Hodder and Stoughton Limited, 1955.

Watson, Natalie K, (chapter title) *The Routledge Companion to the Christian Church* edited by Gerard Mannion and Lewis S. Mudge, (468), New York: Routledge, 2010.

Witherington, Ben. *Women in the Earliest Churches*. Cambridge: Cambridge University Press, 1988.

Witherington, Ben, and Ann Witherington. *Women and the Genesis of Christianity*. Cambridge [England]: Cambridge University Press, 1990.

Wright, N.T. "Romans." In *The New Interpreter's Bible, Vol. 10 General Articles on the New Testament, Gospel of Matthew, Gospel of Mark,* edited by Leander Keck, et al. (p.761). Nashville, TN: Abingdon Press, 1995

Young, Brad H. *Meet the Rabbis – Rabbinic Thought and the Teachings of Jesus* Grand Rapids Michigan, Baker Academic, 2010.

About the author

Rev Tony Lang graduated from St Andrew's United Faculty of Theology at Sydney University in 1969, and was ordained as a minister of the Presbyterian Church of Australia in 1970. He holds the degree of Master of Theology from the University of Newcastle.

Lang has served in parishes in NSW and Qld, spent sixteen years in the Australian Regular Army as a chaplain, over twenty years as a police chaplain in Qld and NSW, and five years as a chaplain at an aged care facility. He has served in parishes in the North Isles of Shetland and in Caithness, North-East Highlands of Scotland. (See website).

He is a member of the Australian Society of Authors and a member of the Fellowship of Australian Writers.

Lang was awarded the Medal of the Order of Australia in 2015. He lives with his wife Janet, Tonkie the Tonkinese cat and Jock the border collie on the shores of Lake Macquarie NSW.

By the same author

Written under the pseudonym of Lachlan Ness:

A Kangaroo Loose in the Top Paddock
A Kangaroo Loose in Shetland
A Kangaroo Loose in Scotland
The Ness Fireside Book of God Ghosts Ghouls and Other True
Stories

Children's Books

Written by Tony Lang

The Magic Mist
An Australian Bush Fantasy
Space Ships

Information about the author and books is at www.lachlanness.com

A Kangaroo Loose in the Top Paddock

There is no fast lane in Deerwood in the high country of the New South Wales north coast. There is, however, a rich cast of characters who help Lachlan Ness, a newly ordained minister of the Presbyterian Church, discover the character and humour of life in rural Australia.

A Kangaroo Loose in Shetland

Lachland and Janet travel to Aberdeen, Scotland, from where they cross hundreds of kilometres of wild North Dea, and arrive in Shetland in a snow storm, unaware of the many adventures that await them among the warm-hearted folk of the North Isles, Britain's remotest islands. Set against the rugged and remote backdrop of the North Isles, Lachlan recounts warm hearted tales of

the wonderful people, and the remarkable beauty of the ancient islands of Shetland.

This heart-warming is a "must-read" for those who may want to visit the North isles and discover for themselves the remarkable beauty that abounds ithe ancient islands of Shetlands,

A Kangaroo Loose in Scotland

Six months in Caithness, Scotland's most north-
erly county, exposes Janet and Lachlan to the
beauty of this wonderful landscape and the inter-
esting and sometimes colourful characters who
cross their path.

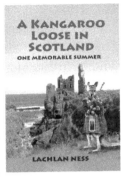

Join Lachlan as he ministers to his congregation
in the Northeast Highlands of Scotland. Visit
lonely Altimarlach, scene of the last clan battle;
and meet the dodgy 'Add-On John'; Wullie, the
old soldier who wanted to be reunited with his leg; and many more
warm and wonderful highland characters.

Here is Lachlan at his quirky best. If you love all things Scottish, you
will love this book.

For these books, and more from
Lachlan Ness and Tony Lang
visit www.lachlanness.com
Place an order and pay with PayPal

E-books can be ordered from Amazon.com.au or
your iBooks online store.

Lightning Source UK Ltd.
Milton Keynes UK
UKHW021825080320
359976UK00019B/386